Portrait
of a Nation

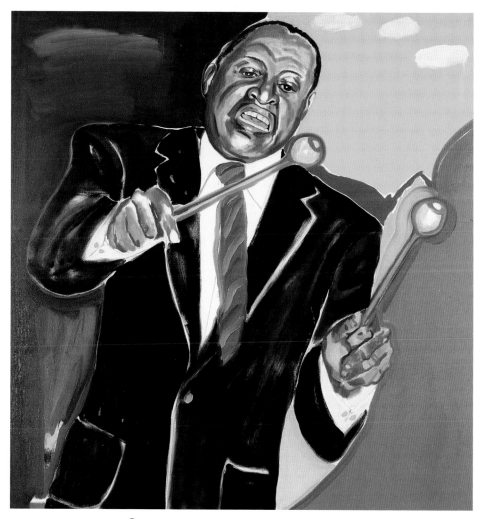

Portrait
of a Nation

LONDON · NEW YORK

**National Portrait Gallery,
Smithsonian Institution**

Contents

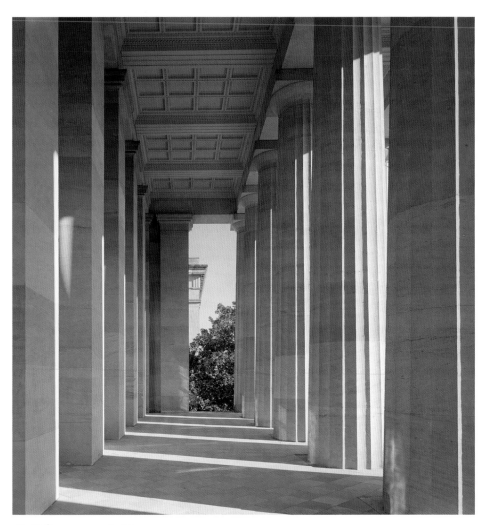

A Director's Tour
**Marc Pachter, National Portrait Gallery at the
Donald W. Reynolds Center for American Art
and Portraiture**

The National Portrait Gallery has always taken pride in being able to trace its origins back to Pierre L'Enfant's intention, in his late eighteenth-century plan for Washington, to create on our very site a place to honor the new nation's heroes. Although this was a goal deferred until the National Portrait Gallery was opened to the public in 1968, its fulfillment attests to the power of L'Enfant's vision of an America that honored those who had made contributions to our nation's vitality, freedom, defense, and imagination.

The building to which the Portrait Gallery returns in the summer of 2006, after more than six years of restoration, has always represented our nation's highest aspirations. In its first iteration, as the Patent Office Building, it was intended to stand as a "temple of invention" and, it might be said, of the American spirit. The building's spaces, returned to the highest standards of its past but refitted for the twenty-first century, now provide the Portrait Gallery with a renewed opportunity to tell the stories of those who have shaped the American experience. This book demonstrates, through representative portraits both on view and in the permanent collection as a whole, our commitment to keeping these remarkable people in the company of their fellow Americans for generations to come.

The visitor entering the National Portrait Gallery from the F Street lobby will first encounter individuals and portraiture from our own time in a series of galleries called "Americans Now," which announces a new turn toward the contemporary in the museum's collections and exhibitions. Since the building closed in 2000, the Portrait Gallery has reexamined an earlier policy of including only those who had died at least ten years before. This has allowed us to collect images of well-known contemporary figures and to initiate a discussion of what constitutes fame and recognition today. The visitor will also see in concurrent galleries the exhibition "Portraiture Now," a changing array of current approaches to portraiture in every medium, testing the state of an art form that continues to reinvent itself.

We include a new feature, "One Life," which will be a gallery devoted to one curator's exploration of the life of an individual. We open with Walt Whitman (see p. 112) and his theme of the American common man.

While the contemporary galleries will change often, our permanent installation, which follows, provides a framework across our history in which visitors can "overhear" a conversation about America—our origins and aspirations—among those significant individuals who did so much to shape that conversation. We begin "American Origins" not at the stirrings of revolution that led to the creation of the United States, but in the swirl of events and of people—both indigenous and from competing European nations—that constituted our earlier history.

In Benjamin Franklin and his contemporaries, we meet the individuals who established a new nation. Unlike so many other countries, the United States began as a political idea, with a sense of both opportunity and uncertainty about its future. Questions about the future hang in the air among those we include in these galleries: will the Union hold, and will the nation prove worthy of its own ideals of justice? Following the establishment of a still-uncertain, expanding democracy, which did not yet include the full participation of all those who lived within its borders, the new nation explores its cultural identity, its territorial boundaries, its new technologies, and its moral possibilities. Within these galleries we meet artists, preachers, soldiers, and militants, and we encounter new ways of portraying them. Following on from the earliest galleries, when all portraits are done in paint, sculpture, coin, and print, we now see the introduction of the daguerreotype and the photographic tradition that followed. Suddenly, many more of our citizens can be portrayed, and many more images of the famous—and even of the infamous—can flood our society. The audiovisual and new media revolution of the twentieth and twenty-first centuries will only expand this trend and expand, too, the idea of what constitutes a portrait.

The Portrait Gallery devotes some of the most expansive spaces in "American Origins" to the Civil War, where the question of the viability of our union is laid to rest and the question of justice for all Americans is tested but not yet resolved. In these galleries we see the warriors both of political struggles and of the battlefield. We see individuals who no longer feel bound in common citizenship with their neighbors to the north and south and individuals who demand citizenship not yet attained because of race and slavery. It is the cauldron out of which modern America will emerge. Two galleries take us to the end of that century of upheaval with the raucous sound of an expanding capitalism, a new taste for internationalism, waves of immigration, and the closing of the American frontier.

On the Gallery's second floor, the visitor will meet the American presidents. The exploration of that great institution of our political life as a democracy is anchored in the Gallery's premier work, Gilbert Stuart's "Lansdowne" portrait of George Washington (see p. 38). Painted in 1796, the last year of Washington's presidency, it is the defining image of an office that the world had never before seen. The Portrait Gallery has almost tripled the space devoted to the presidents and has presented a range of images, capturing the many dimensions of the office, through formal portraits, candid images, and even the caricatures that afflict the mighty in our society. Adjacent spaces explore aspects of the presidency such as decision-making in eras of national crisis.

The rest of the second floor is devoted to temporary exhibitions on the many themes of American biography and portraiture. For the visitor who wants to explore the Portrait Gallery's permanent collection in the context of the twentieth century, the third floor offers that opportunity in the brilliantly ornate Great Hall (see p. 10). Four galleries introduce the figures who help to define our political life, our cultural and scientific life, our role in the world, and our continuing struggle for social justice.

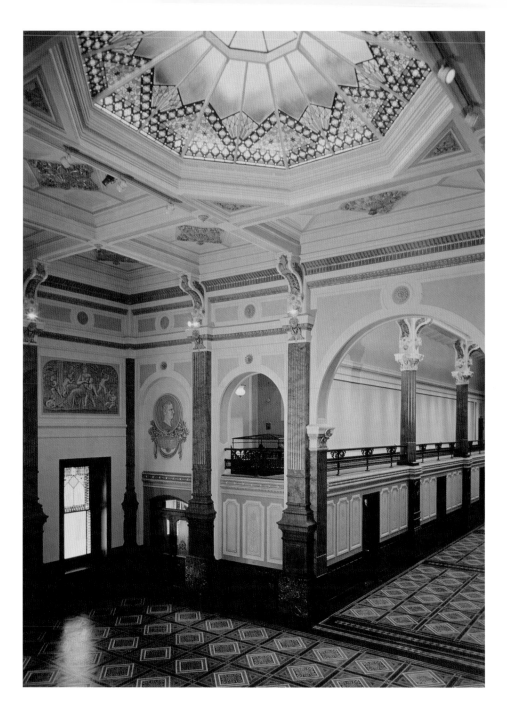

Among the Gallery's collections that enrich the portrayal of our tumultuous times are the *Time* cover collection, our burgeoning photography collection, and the wide range of works by the sculptor Jo Davidson, whose buddha-like depiction of Gertrude Stein (see p. 138) is one of the museum's treasures. In two mezzanine spaces, the vitality of American twentieth-century life is presented through "Champions," a look at our sports tradition, and "Bravo," an exuberant depiction of America's stars of the performing arts.

I have been known to call the Portrait Gallery a "dinner party with history." What I mean is that visiting here is like going to a place filled with the most extraordinary people one would ever hope to meet. They are women and men who come from everywhere in the country and the world, whose cultural origins and fields of achievement are as varied as the society in which we live and who have had the good fortune to be captured on canvas, on film, on paper or in marble or bronze by artists who have responded to their spirit, and given them the chance to be introduced to generations to come.

Welcome to our world and yours.

The Portraits:
1616–1899

Pocahontas, the Indian princess who allegedly saved the life of the English colonist John Smith, survives and flourishes as an example of an early American heroine. While Smith may have embellished the story of his rescue, the importance of Pocahontas to relations between colonists and Native Americans is undisputed. Following her conversion to Christianity and marriage to the Englishman John Rolfe, Pocahontas journeyed to England with her family to demonstrate the ability of new settlers and native tribes to coexist in the Virginia colony. While in England, Pocahontas sat for her portrait, which was afterwards engraved. That print served as the basis for this later portrait. The painter included an inscription beneath his likeness, copied from the engraving, but through an error in transcription misidentifies her husband as Thomas, the name given to their son. ACG

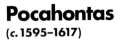

Pocahontas

(c. 1595–1617)

Unidentified artist
Oil on canvas, 30½ x 25½ ins
(77.5 x 64.8 cm), after 1616
Gift of the A.W. Mellon Educational
and Charitable Trust
NPG.65.61

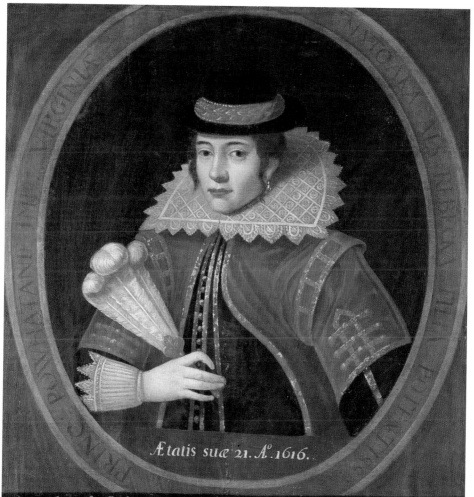

Ætatis suæ 21. Aº. 1616.

Matoaks als Rebecka daughter to the mighty Prince
Powhatan Emperour of Attanoughkomouck als Virginia
converted and baptized in the Christian faith, and
Wife to the worll Mr Tho: Rolff.

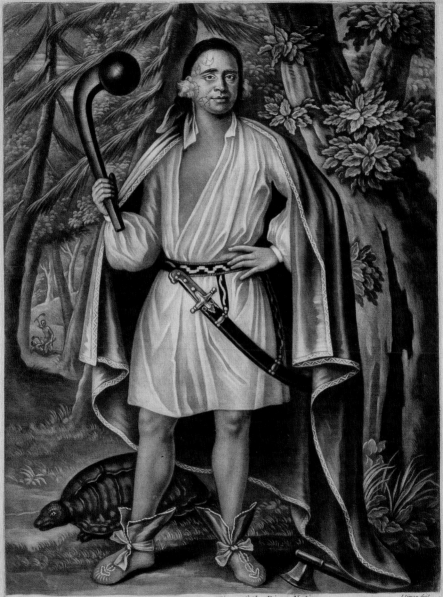

I. Verelst Pinx.ᵗ E T O W O H K O A M, *King of the River Nation.* I. Simon fecit.

Printed for Inᵒ Bowles & Son, at the Black Horse in Cornhill London.

2

The Mohawk chief E Tow Oh Koam was one of five Iroquois leaders who met Queen Anne and her court in April 1710. Accompanied by Colonel Pieter Schuyler, the mayor of Albany, this delegation traveled to London, hoping to strengthen the tribe's political and trading alliance with England. Since the outbreak of Queen Anne's War in 1702, the French had been regularly raiding poorly protected English settlements in upstate New York. Although the Iroquois tribes had provided the English with some military assistance, the pleas of English colonists for help in this struggle had fallen largely on deaf ears back in England. E Tow Oh Koam and his fellow delegates convinced Queen Anne to commit the resources to help defend the contested border, thereby hastening the war's end and formalizing an alliance that endured throughout much of the eighteenth century. FHG

E Tow Oh Koam
(dates unknown)

John Simon (1675–*c*. 1755), after John Verelst
Mezzotint, 13^1/$_2$ x 10^1/$_{16}$ ins (34.3 x 25.5 cm), 1710
NPG.74.23

Anne Catharine Hoof married the printer Jonas Green, future editor of the *Maryland Gazette*, in 1738, bore fourteen children, and, like the good Dutch housewife she was trained to be, helped as necessary in her husband's business. Jonas died in 1767, and the widow Green succeeded him as Maryland's public printer. She continued to print the *Gazette*, recording opinions and events leading up to the American Revolution.

Mrs. Green's obituary lauded her only as a wife and mother, "for conjugal Affection, and parental Tenderness, an Example to her sex." But Charles Willson Peale, showing her with her newspaper in hand, indicates she was also a professional woman—one of the few of her era. MCC

Anne Catharine Hoof Green
(died 1775)

Charles Willson Peale (1741–1827)
Oil on canvas, 36 x 28 ins (91.4 x 71.1 cm), 1769
Gallery purchase, with funding from the
Smithsonian Collections Acquisitions
Program and gift from the Governor's
Mansion Foundation of Maryland
NPG.91.152

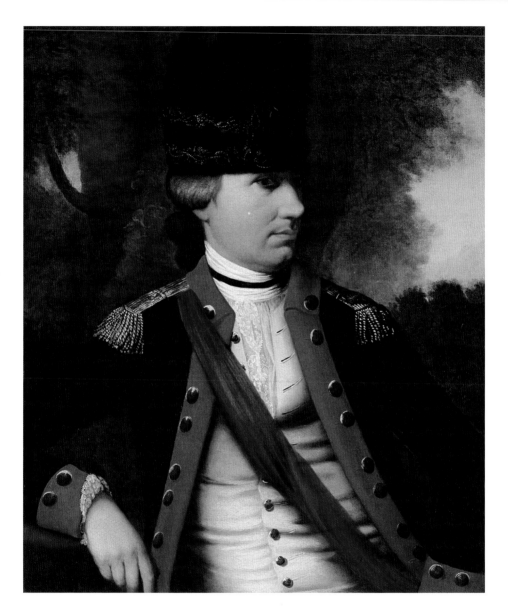

Charles Cotesworth Pinckney posed for his portrait around 1773 in the red coat (traces of which are still discernible) of the Charles Town (now Charleston, South Carolina) colonial militia. By 1775, despite formative years spent in England, Pinckney was an enthusiastic rebel. He asked the artist Henry Benbridge to repaint the uniform, showing him as a captain in the second South Carolina regiment raised to fight against the British. Pinckney, a friend remarked, had "a passion for glory and Zeal for the cause of his country."

Military glory eluded Pinckney—he was fated to participate in a string of defeats, never in victory—but seven years of faithful service won him the rank of brigadier general at the close of the war. Pinckney made his mark not as a soldier, but as a framer of the Constitution, an envoy to revolutionary France, and a Federalist presidential candidate. MCC

Charles Cotesworth Pinckney
(1746–1825)

Henry Benbridge (1743–1812)
Oil on canvas, $30^{3}/_{16}$ x $25^{3}/_{16}$ ins
(76.7 x 64 cm), c. 1773
NPG.67.1

Phillis Wheatley was the first African American to publish a book and the first American woman to earn a living from her writing—no small feat considering that she came to the colonies as a slave. Although most slaves had no opportunity to gain an education, within two years of being purchased in 1761 Wheatley had learned to read and begun to write poetry. Her elegy for celebrated minister George Whitefield caught audiences' attention. It also prompted the publication of *Poems on Various Subjects, Religious and Moral* (1773), which drew the praise of Washington, Franklin, and Voltaire, and helped Wheatley to gain her freedom. HL/FHG

Phillis Wheatley
(c. 1753–1784)

Unidentified artist, after Scipio Moorhead
Engraving, 5^1/$_{16}$ x 4 ins (12.8 x 10.1 cm), 1773
NPG.77.2

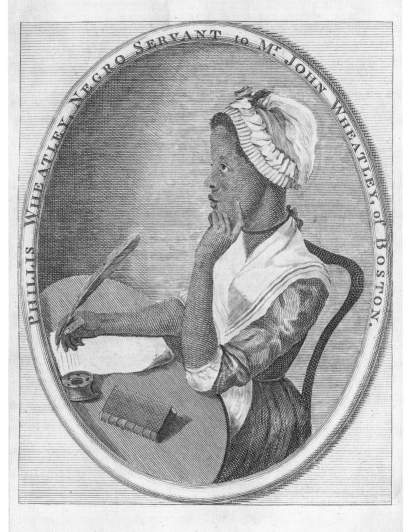

PHILLIS WHEATLEY NEGRO SERVANT to Mr. JOHN WHEATLEY, of BOSTON.

Published according to Act of Parliament, Sept.r 1, 1773 by Arch.d Bell, Bookseller No. 8 near the Saracens Head Aldgate.

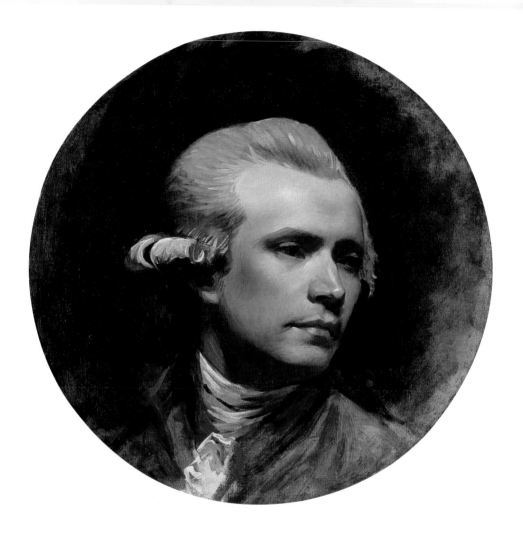

John Singleton Copley, proclaimed John Adams, is "the greatest Master, that ever was in America." While still a teenager, Copley was capable of gratifying Bostonians' desire for realistic portraits; by the time he was twenty, the essentially self-taught artist was painting better pictures than he had ever seen. Frustrated by the limitations of his provincial environment, where people, he complained, generally regarded art as "no more than any other useful trade," Copley longed to go to Europe to study. In the wake of the Boston Tea Party of December 1773—his father-in-law was one of the merchants who were supposed to receive the tea dumped in the harbor— the increasing political turmoil spurred his departure for England in June 1774. There, in the flush of new success, he painted his own likeness. He never returned to America. MCC

John Singleton Copley
(1738–1815)

Self-portrait
Oil on canvas, 22 1/4 ins (56.5 cm) diameter, 1780–84
Gift of the Morris and Gwendolyn Cafritz Foundation, with matching funds from the Smithsonian Institution
NPG.77.22

President George Washington chose John Jay to be the first chief justice of the United States. Jay had played an important part in negotiating the treaty bringing the Revolutionary War to a close, and was the postwar secretary of foreign affairs. An advocate for a stronger national government, Jay had helped persuade New Yorkers to ratify the Constitution, contributing five newspaper essays to the series that became known as the *Federalist Papers*.

In 1794, when war with England threatened, Washington sent Chief Justice Jay to London to defuse the crisis. The treaty that Jay negotiated, which Jeffersonian Republicans seized upon as a repudiation of America's wartime alliance with France and a return to English dominance, set off the cry of "Damn John Jay." Nonetheless, the controversial Jay Treaty avoided a war that the young Republic was ill-equipped to wage. MCC

John Jay
(1745–1829)

Gilbert Stuart (1755–1828) and
John Trumbull (1756–1843)
Oil on canvas, 50½ x 40 ins (128.3 x 101.6 cm),
begun 1784, completed by 1818
NPG.74.46

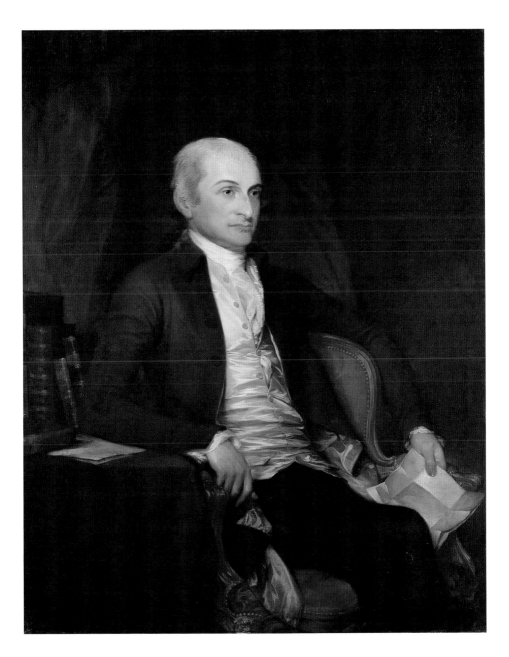

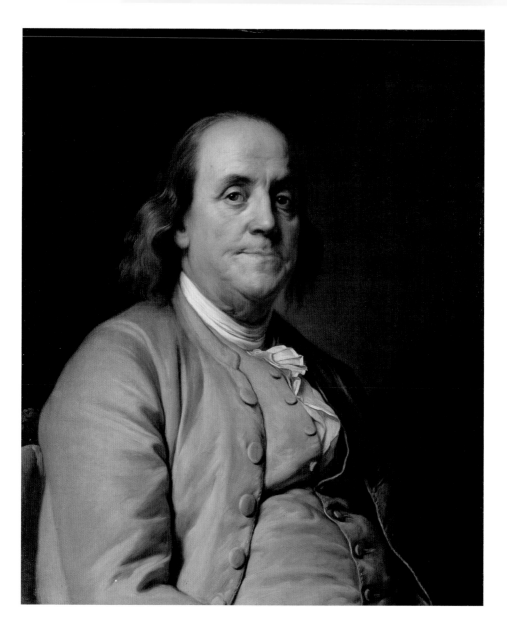

Benjamin Franklin, in his day the most famous American in the world, returned from his years representing colonial interests in England just in time to be unanimously elected to represent Pennsylvania at the Second Continental Congress. Behind him was a lifetime of achievement as a printer, an unsurpassed author of wit and wisdom, an inventor, and a scientist. Ahead were his roles as a signatory of the Declaration of Independence and as a member of the Constitutional Convention of 1787. In between was his triumph as a diplomat in France, where this portrait was ordered by Madame Brillon de Jouy, who loved Franklin's "droll roguishness which shows that the wisest of men allows his wisdom to be perpetually broken against the rocks of femininity."

In 1995, this portrait was selected as the basis for Franklin's engraving on the redesigned $100 bill. MCC

Benjamin Franklin
(1706–1790)

Joseph Siffred Duplessis (1725–1802)
Oil on canvas, 28½ x 23½ ins
(72.4 x 59.7 cm), c. 1785
Gift of the Morris and Gwendolyn
Cafritz Foundation
NPG.87.43

Daniel Shays (left), a Revolutionary War captain, gave his name to the 1786–87 tax rebellion in western and central Massachusetts. Armed farmers, threatened with the loss of their farms and imprisonment for debt, forced the closing of the courts and marched upon the arsenal at Springfield. The militia was called out, the insurrection at length put down, most of the rebels pardoned (Shays fled to Vermont), and their grievances addressed by the state legislature. Most significantly, Shays's Rebellion frightened conservatives throughout the country and gave an urgency to the need for a stronger central government. MCC

Daniel Shays
(1747–1825) with Job Shattuck

Unidentified artist
Relief cut, 3^{9}/₁₆ x 5^{1}/₁₆ ins (9 x 12.9 cm), 1787
Published in *Bickerstaff's Boston Almanack for 1787* (3rd edition, Boston)
NPG.75.25

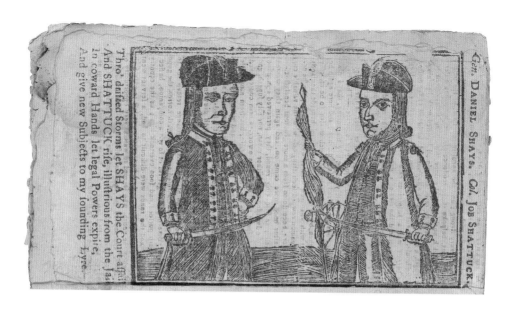

Gen. DANIEL SHAYS, Col. JOB SHATTUCK.

Thro' dreadful Storms let SHAYS the Court affail,
And SHATTUCK rife, illustrious from the Jail,
In coward Hands let legal Powers expire,
And give new Subjects to my founding Lyre.

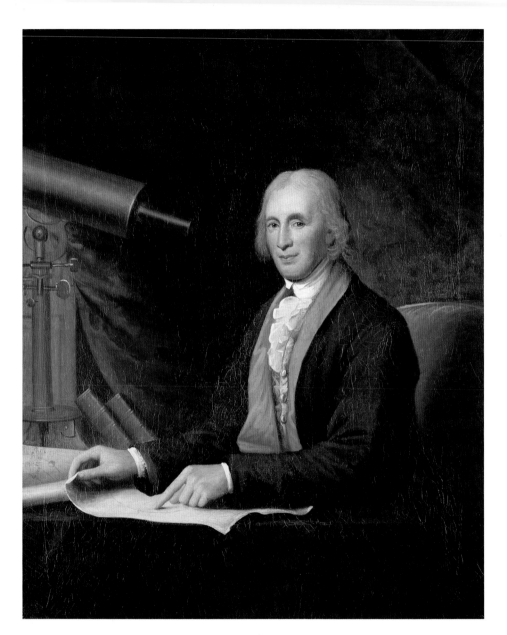

A clockmaker by trade and a self-taught mathematician and astronomer, David Rittenhouse was second only to Benjamin Franklin as the foremost man of science in eighteenth-century America. His surveying instruments were unsurpassed; his astronomical calculations were solicited by almanac publishers near and far; and his orrery (a mathematically precise model of the solar system) was touted as the greatest mechanical wonder of the new world, more complete than anything that could be obtained in Europe. Rittenhouse's name, said the physician and patriot Dr. Benjamin Rush, "gave splendor to the American character."

Charles Willson Peale painted his friend (and collaborator in experiments to improve rifles during the Revolution) seated before a large reflecting telescope—perhaps the one bequeathed to him by Benjamin Franklin—pointing to a comet in orbit. MCC

David Rittenhouse
(1732–1796)

Charles Willson Peale (1741–1827)
Oil on canvas, 49 x 39½ ins
(124.5 x 100.3 cm), 1796
Bequest of Stanley P. Sax
NPG.98.73

Gilbert Stuart was commissioned to paint this portrait after the success of his first portrait of George Washington in 1795. Martha Washington persuaded the president to sit again because, according to artist Rembrandt Peale, she "wished a Portrait for herself; he therefore consented on the express condition that *when finished* it should be hers." Stuart, however, preferred this portrait to his earlier *Washington*; he purposely left it and that of the first lady unfinished so that he could use this as a model for the numerous copies that the first president's admirers commissioned. After Stuart's death, the two paintings were purchased for the Boston Athenaeum, which owned them for more than 150 years.

This image served as the basis for the engraving of Washington on the one-dollar bill. John Neal, an early nineteenth-century writer and art critic, wrote, "Though a better likeness of him were shown to us, we should reject it; for, the only idea that we now have of George Washington, is associated with Stuart's Washington." FSV

George Washington
(1732–1799), "Athenaeum" portrait

Gilbert Stuart (1755–1828)
Oil on canvas, 48 x 37 ins
(121.9 x 94 cm), 1796
Owned jointly with the Museum
of Fine Arts, Boston
NPG.80.115

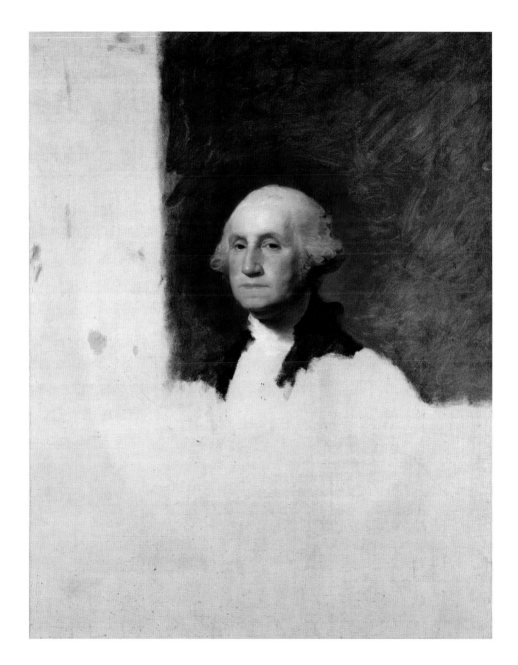

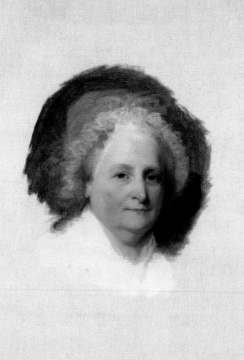

Gilbert Stuart painted this portrait of Martha Washington at the same time as he did that of the president (see p. 34). Both paintings were commissioned by the Washingtons. They were never completed, however, and the artist kept them in his possession until his death. Although Stuart made many copies of the president's portrait, no other likeness of Martha Washington by Stuart is known to exist. FSV

Martha Washington
(1731–1802)

Gilbert Stuart (1755–1828)
Oil on canvas, 48 x 37 ins (121.9 x 94 cm), 1796
Owned jointly with the Museum
of Fine Arts, Boston
NPG.80.116

The general who led Americans to victory in the American Revolution, and the first president, George Washington was often depicted, and it seemed everyone wanted the hero's likeness. But it is this portrait that stands for all time as the image that best represents what he meant to the new nation and still means today. It is the one picture that we can say ranks in importance with those sacred founding documents, the Declaration of Independence, the Constitution, and the Bill of Rights.

We see Washington in 1796, the last year of his two-term presidency. Earlier full-length portraits show him in military uniform, but here he is in civilian dress, revealing that in this democracy the elected executive is the true commander-in-chief. He stands in elegant surroundings suggesting traditional European grandeur, but he is nonetheless not draped like a king, which he refused to be; he is powerful only by the people's consent. This was the man who told the American people what an elected president could be and whose resolve gave them confidence in their future. The rainbow behind him breaks through a stormy sky.

Washington was lucky in his portraitist. American Gilbert Stuart had eighteen years in Europe to hone his artistry. This commission by Senator and Mrs. William Bingham of Pennsylvania was a gift for the Marquis of Lansdowne, an English supporter of American independence. It was copied by Stuart and others as *the* image of the man who sustains the national purpose—the man every generation of Americans needs to rediscover. MP

George Washington
(1732–1799), "Lansdowne" portrait

Gilbert Stuart (1755–1828)
Oil on canvas, 97½ x 62½ ins
(247.6 x 158.7 cm), 1796
Acquired as a gift to the nation through the generosity of the Donald W. Reynolds Foundation
NPG.2001.13

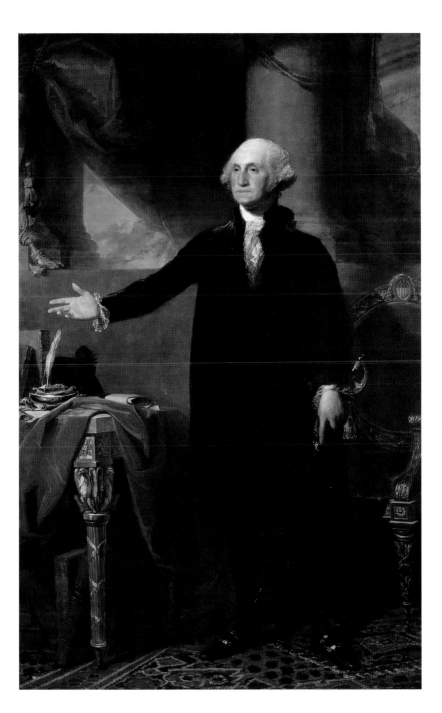

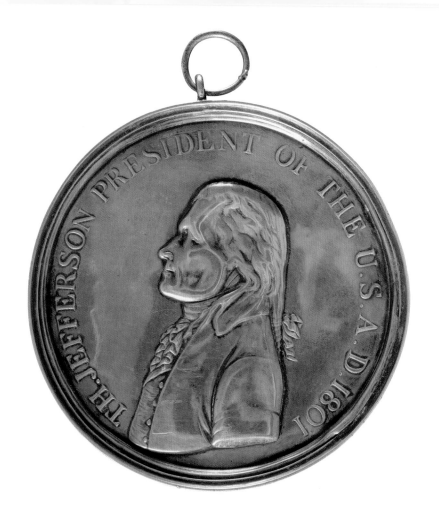

Peace medals are an important part of the history of U.S. presidential portraiture and also an essential element in federal Indian policy. Presented to Indian chiefs on such important occasions as the signing of a treaty or a visit to the nation's capital, the medals gave rank and distinction, and many were passed down from generation to generation.

In the first half of the nineteenth century, the design of medals, such as this one of Thomas Jefferson, was determined by the need to win the allegiance of the Indians. Medals contained the likeness of the president on one side and symbols of peace and friendship on the other. Acceptance of a medal marked the Indian's friendship and loyalty to the United States. By midcentury, the medals encouraged assimilation of the Indian into American society. FSV

Thomas Jefferson
(1743–1826)

Robert Scott (active 1781–1820)
Silver, 4 ins (103 cm) diameter, 1801
Gift of Betty A. and Lloyd G. Schermer
NPG.99.108

Thomas Jefferson's tombstone notes, by his own instruction, that he authored the Declaration of Independence, founded the University of Virginia, and was responsible for Virginia's Statute for Religious Freedom. But it fails to mention that this philosopher, inventor, and scientist was also president of the United States. This does not mean that his administration lacked significance. During Jefferson's presidency, the nation acquired from France the vast wilderness known as the Louisiana Purchase and successfully stood its ground against extortion attempts from Barbary Coast pirates in the Mediterranean. These early successes, however, paled in comparison to the wrath later heaped on Jefferson in the wake of the economically disastrous trade embargo he imposed in response to British and French interference with U.S. shipping. A much-beleaguered Jefferson ended his presidency by calling it a best-forgotten "splendid misery."

Gilbert Stuart was not only early America's most admired portraitist but also an eccentric known for procrastinating. After sitting for this portrait in 1805, Jefferson had to wait sixteen years before it was finally delivered. FSV

Thomas Jefferson
(1743–1826)

Gilbert Stuart (1755–1828)
Oil on wood panel, 26 1/8 x 21 ins
(66.4 x 53.3 cm), 1805–21
Owned jointly with Monticello, Thomas
Jefferson Foundation, Inc., Charlottesville,
Virginia; purchase funds provided by the
Regents of the Smithsonian Institution,
the Trustees of the Thomas Jefferson
Foundation, Inc., and the Enid and Crosby
Kemper Foundation; NPG.82.97

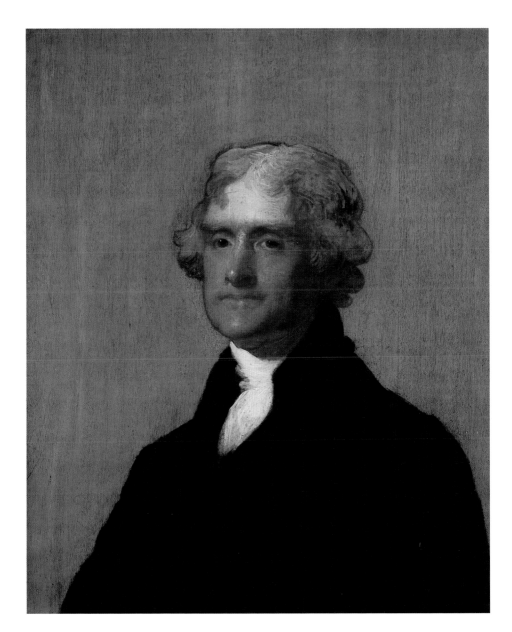

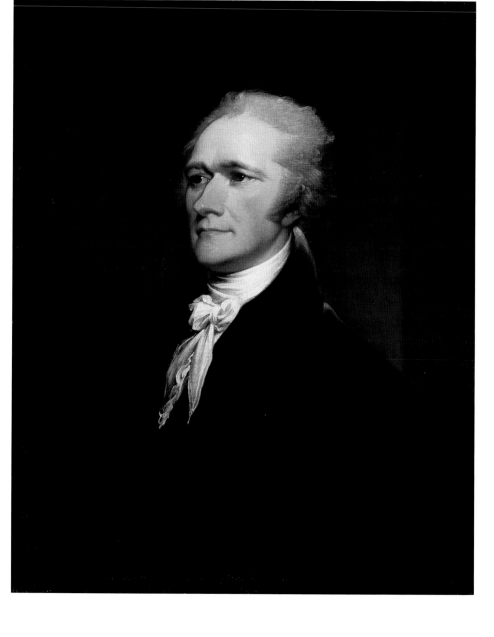

Alexander Hamilton—"the bastard brat of a Scotch pedlar," as John Adams dubbed him—immigrated to America as a teenager and quickly found a fertile field for his brilliance and drive. By the time George Washington appointed him the first secretary of the treasury in 1789, Hamilton had achieved success in war and in marriage; reputation in the law and politics; and fame as the instigator and author, with James Madison and John Jay (see p. 26), of the *Federalist Papers*.

Overriding Thomas Jefferson's notion of America as an agrarian paradise of yeoman farmers (and thus sparking the rise of political parties), Hamilton—whose policies were intended to cement the moneyed interests to the new government—dominated Washington's administration. He restored public credit and laid the groundwork for the nation's banks, commerce, and manufacturing, paving the way for the United States to become a modern, industrialized nation. MCC

Alexander Hamilton
(1755–1804)

John Trumbull (1756–1843),
after Giuseppe Ceracchi
Oil on canvas, 30½ x 24½ ins
(77.5 x 62.2 cm), 1806
Gift of Henry Cabot Lodge
NPG.79.216

A pioneer in the establishment of independent African American churches, Thomas Paul was educated at the Free Will Baptist Church in Hollis, New Hampshire, and came to Boston as an itinerant preacher. In August 1805, he led the effort to found the African Baptist Church, and by the end of the year a meeting house (which stands today as the oldest surviving African American church building in America) was completed on Beacon Hill. During the next twenty-five years, Paul exerted strong leadership over a growing congregation and won fame as he expanded his missionary work. Famed diarist Reverend William Bentley of Salem went to hear Paul speak and recorded: "He impressed the audience with a regard to his sincerity & many with a sense of his talents. His person is good." MCC

Thomas Paul
(1773–1831)

Thomas Badger (1792–1868)
Oil on wood panel, 8 x 6½ ins
(20.3 x 16.5 cm), c. 1825
NPG.70.45

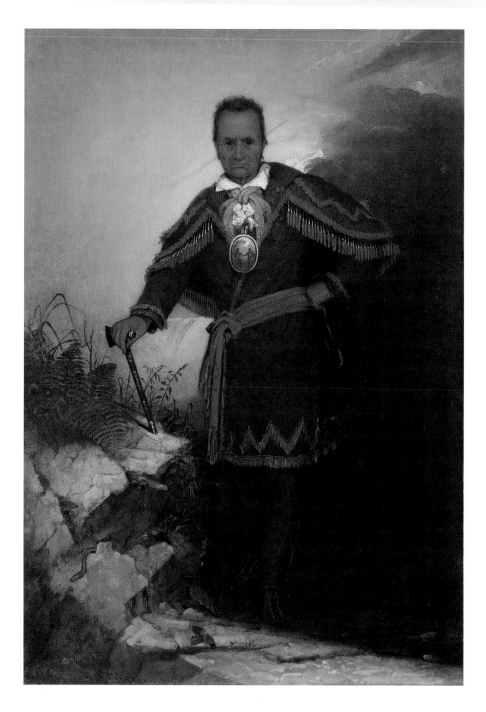

The Seneca chief Sagoyewatha, a swift runner for the British during the American Revolution, was given the name Red Jacket from the scarlet coats he habitually wore. During the War of 1812 against Britain he cast in his lot with the Americans, but after participating in several battles, including the Battle of Chippewa, he proposed that Indians fighting on both sides of the conflict withdraw from the war, and he went home.

Sagoyewatha's claim to celebrity was not as a warrior, but as an orator. An eloquent defender of Indian land claims and culture, he detested Christianity and white civilization. Nonetheless, in his many portraits he proudly wears the peace medal presented to him by President Washington in 1792 when he went to Philadelphia to assert Seneca claims and grievances. MCC

Sagoyewatha (Red Jacket)
(c. 1758–1830)

Thomas Hicks (1823–1890),
after Robert W. Weir
Oil on canvas, 32 x 22 ins (81.3 x 55.9 cm),
1868 after 1828 original
NPG.2002.69

The career of Ira Aldridge illustrates the costs that racism inflicted on African Americans and on America itself. Aldridge was one of the great actors of his age—but he was black. Unable to work in America, he moved to England in the 1820s and lived abroad until his death. Aldridge's most famous role was Othello, in which he is shown here, a part that he invested with the poignancy of his own experience; a Russian critic wrote in 1858 that "he was Othello himself, as created by Shakespeare." Yet Aldridge was not bound by color in his acting. He played most of Shakespeare's main characters, especially the tragic heroes. Aldridge's career foreshadows the fate of many African American artists, such as dancer Josephine Baker or jazz musician Dexter Gordon, who went to Europe to practice their art. DCW

Ira Aldridge
(1805–1867)

Henry Perronet Briggs (c. 1791–1844)
Oil on canvas, 50½ × 40¾ ins
(128.3 × 103.5 cm), c. 1830
NPG.72.73

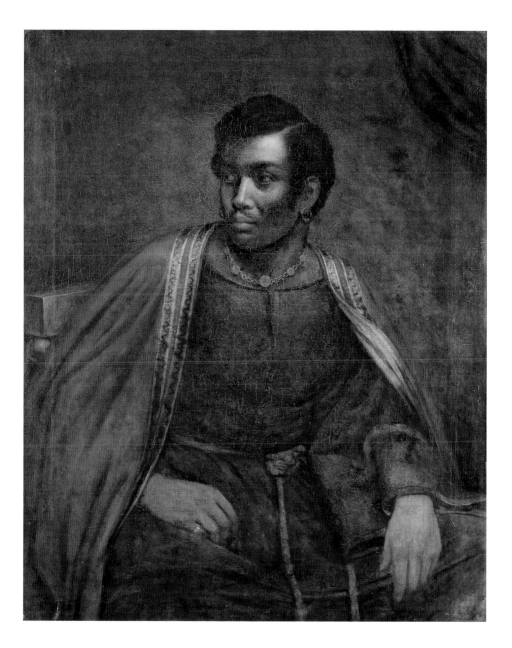

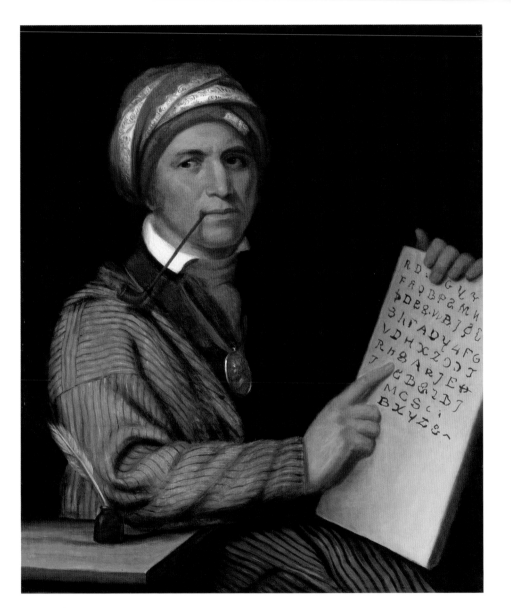

Sequoyah, the son of a Cherokee chief's daughter and a fur trader from Virginia, was a warrior and hunter and, some say, a silversmith. For twelve years he worked to devise a method of writing down the Cherokee language. His syllabary of eighty-five symbols, representing vowel and consonant sounds, was approved by the Cherokee chiefs in 1821, and the simple utilitarian system made possible a rapid spread of literacy throughout the Cherokee nation. Medicine men set down ceremonies for healing, divination, war, and traditional ball games; missionaries translated hymns and the New Testament into the native language; and in 1828 the *Cherokee Phoenix*, a weekly bilingual newspaper, began publication at New Echota, Georgia.

 The original portrait of Sequoyah, painted by Charles Bird King, was destroyed by the fire that swept through the Smithsonian Castle building in January 1865. MCC

Sequoyah
(c. 1770– c. 1843)

Henry Inman (1801–1846),
after Charles Bird King
Oil on canvas, 30¼ × 25¼ ins
(76.8 × 64.1 cm), *c.* 1830
NPG.79.174

Unlike his solitary predecessor Daniel Boone, Davy Crockett created the image of the frontiersman as a jocular, colorful "type" who loved tall tales, whisky, and cutting a caper. Crockett was a bad farmer and kicked around the Southeast, serving in the military and minor governmental offices. On a whim he ran for Congress from Tennessee, serving two terms (1827-31 and 1833-35). To capitalize on his political fame, he penned an autobiography containing the motto "Be always sure you're right—then go ahead," which has been the credo of the frontiersman, in reality and myth, to the present day. After Congress, Crockett created a road show in which he presented himself to civilized eastern audiences as the wild and woolly backwoodsman, "half man, half alligator." Still restless, however, Crockett joined the fight for Texan independence and was killed at the Alamo. DCW

Davy Crockett
(1786–1836)

Chester Harding (1792–1866)
Oil on canvas, 30 x 25 ins (76.2 x 63.5 cm), 1834
Future bequest of Ms. Katharine Bradford
L/NPG.1.88

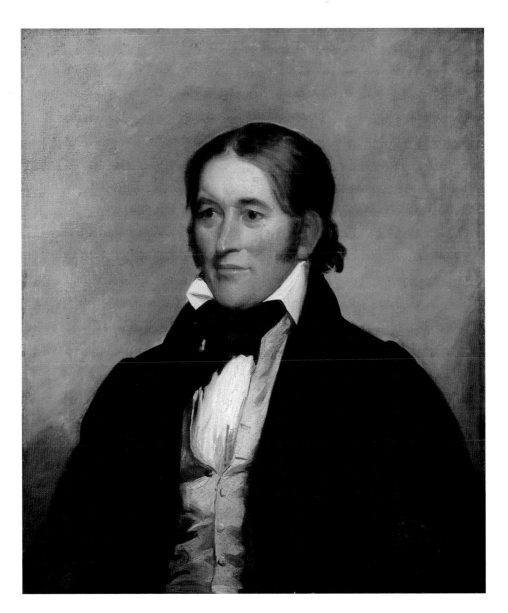

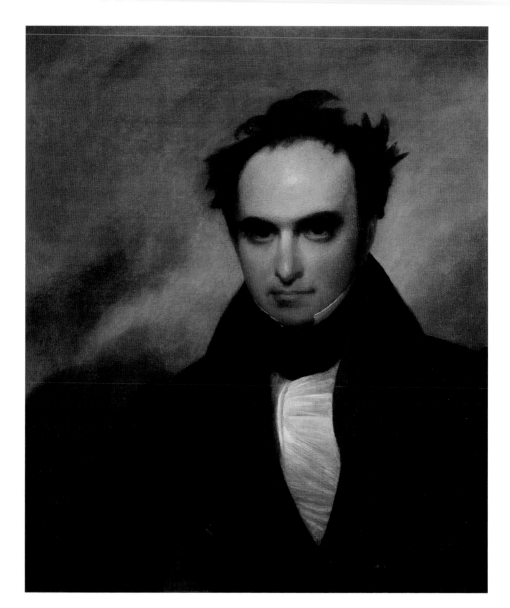

If John C. Calhoun (see p. 64) was the South's leading advocate of states' rights in the antebellum United States, New England's Daniel Webster was easily its most celebrated opponent. Endowed with an imposingly broad brow that seemed to underscore his eloquence in the Senate and courtroom, Webster was unmatched in his gift for speaking. In 1830, he held his audience enthralled as he turned an exchange with South Carolina senator Robert Hayne into a debate over states' rights. Ending his oration with "Liberty and Union, now and forever, one and inseparable," he left his listeners spellbound, and it was many minutes before any dared to speak. From that moment, Webster was for many a living emblem of national unity.

Francis Alexander painted this portrait in 1835 to commemorate Webster's role in an 1818 Supreme Court case that protected Dartmouth College's charter from being negated. JGB

Daniel Webster
(1782–1852)

Francis Alexander (1800–1880)
Oil on canvas, 30 x 25 ins (76.2 x 63.5 cm), 1835
Bequest of Mrs. John Hay Whitney
NPG.98.71

Andrew Jackson of Tennessee, fighter of Indians and hero of the Battle of New Orleans—the first president of truly humble background and the first from a western state (as Tennessee then was)—ushered in a new political era. His supporters hailed him as "The People's President"; conservatives saw his election as the ascent of "King Mob."

Before his two terms in office were out, Jackson had vetoed more legislation than the previous presidents combined. And unlike his predecessors, who invoked that power on strictly constitutional grounds, Jackson vetoed key congressional measures, not because he deemed them illegal, but simply because he did not like them. In doing so, he set a precedent that vastly enlarged the presidential role in congressional lawmaking.

Among Jackson's opponents, this executive activism drew charges of dictatorship. Those accusations, however, carried little weight among yeoman farmers and laborers, who doted on Jackson's professed opposition to elitism. MCC/FSV

Andrew Jackson
(1767–1845)

Ferdinand Pettrich (1798–1872)
Marble, height 25½ ins (64.8 cm)
(without base), replica of 1836 original
NPG.91.45

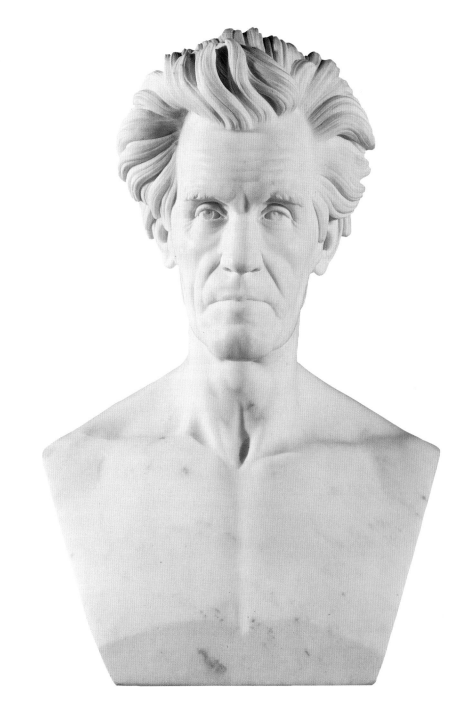

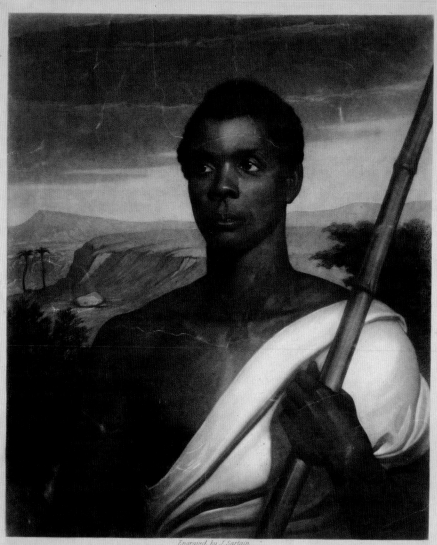

Engraved by J. Sartain.

Cinque

Cinqué was the slave name given to Singbe-Pieh by the Spanish who illegally enslaved him and fifty-one others in 1839. While sailing to Cuba, Singbe-Pieh led a successful mutiny of the slave ship *Amistad*. But the Africans then had to rely on a Spanish helmsman, who steered the ship to Long Island instead of back to Africa. The *Amistad* was secured by U.S. authorities, and the slaves were interned in New Haven. While the federal government, fearful of offending the South, wanted to recognize the law of property and return the slaves to their owners, the District Court in New Haven ordered them freed. When the government appealed, ex-president John Quincy Adams defended the *Amistad* prisoners before the Supreme Court, successfully arguing that the right of *habeas corpus* prohibited their illegal seizure. Singbe-Pieh and his fellow captives were returned to Africa. DCW

Cinqué
(c. 1817– c. 1879)

John Sartain (1808–1897),
after Nathaniel Jocelyn
Mezzotint, 9¹/₈ x 7¹/₂ ins
(23.2 x 19.1 cm), *c*. 1840
NPG.69.66

His admirers called him "Gallant Harry," and his impetuous charm made him quite possibly the most beloved politician of his generation. But the real legacy of Kentucky's Henry Clay was his unstinting devotion, in the House of Representatives and later in the Senate, to maintaining a strong American union. In the early 1830s, as southern states threatened to nullify federal authority over a tariff bill that would have hurt plantation economies, Clay set aside his own preference for the new law to orchestrate a compromise. In 1850, with the North and South on the verge of armed conflict over the extension of slavery into the new western territories, Clay again stepped in with proposals that, temporarily at least, satisfied both sections. This last act of his career earned him the title of Great Pacificator. JGB

Henry Clay
(1777–1852)

John Neagle (1796–1865)
Oil on canvas, $27^3/_4 \times 21^3/_4$ ins
(70.5 × 55.2 cm), 1842
NPG.93.476

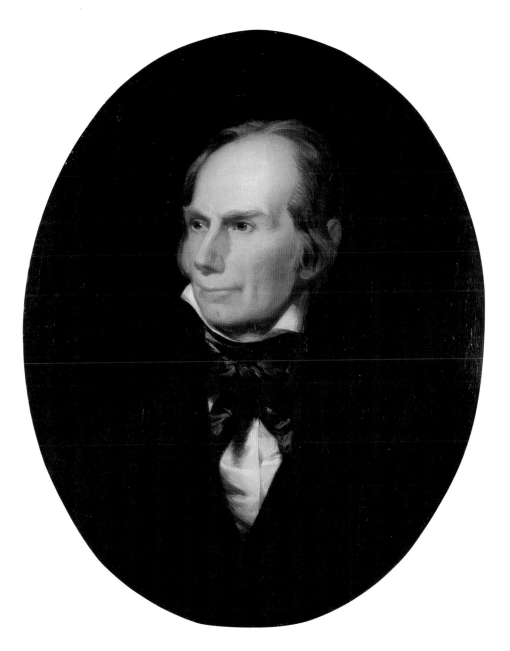

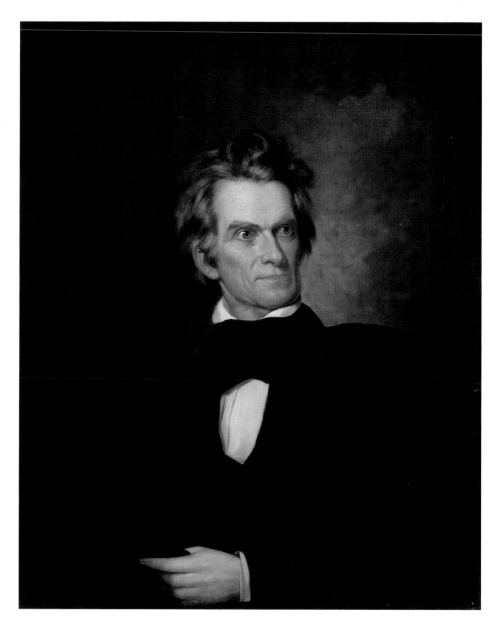

South Carolina's John C. Calhoun was a formidable presence in American politics for nearly four decades. During that time, he served twice as vice president and sat in two cabinets. It was during his later years in the Senate, however, that he had his greatest impact, as a champion of southern interests and formulator of a sectional dogma of states' rights. But even as he defended the South against attempts to curb slavery and argued for the right of states to reject federal policies, he sensed that he was fighting a losing battle. His dying words in 1850 were "The South, the poor South."

One of five known versions of the likeness that the artist George P.A. Healy made from sittings with Calhoun in 1844, this portrait originally belonged to Calhoun himself. JGB

John C. Calhoun
(1782–1850)

George Peter Alexander Healy (1813–1894)
Oil on canvas, 36³/₁₆ x 29³/₁₆ ins
(91.9 x 74.1 cm), c. 1845
NPG.90.52

The earliest-known likeness of the radical abolitionist John Brown, this portrait was made by the pioneering African American daguerreotypist and fellow abolitionist Augustus Washington. In a pose that dramatizes his antislavery activism, Brown stands with one hand raised, as if repeating his public pledge to dedicate his life to the destruction of slavery.

With his other hand, he grasps what is believed to be the standard of his "Subterranean Pass Way"—the militant alternative to the Underground Railroad that Brown sought to establish in the Allegheny Mountains more than a decade before his ill-fated raid on the arsenal at Harpers Ferry. AMS

John Brown
(1800–1859)

Augustus Washington (1820/21–1875)
Quarter-plate daguerreotype,
$4^1/_2 \times 3^7/_8$ ins (11.4 x 9.9 cm), c. 1846–47
Purchased with major acquisitions
funds and with funds donated by
Betty Adler Schermer in honor of her
great-grandfather, August M. Bondi
NPG.96.123

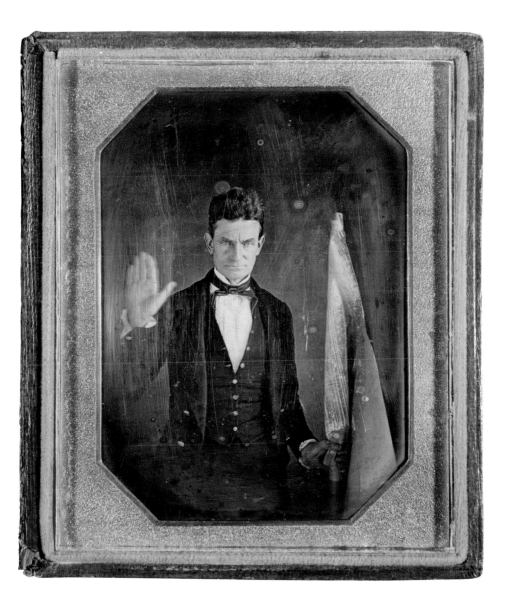

In the years following his escape from bondage in 1838, former slave Frederick Douglass emerged as a powerful and persuasive spokesman for the cause of abolition. Douglass's effectiveness as an antislavery advocate was due in large measure to his firsthand experience of the evils of slavery and his extraordinary skill as an orator whose "glowing logic, biting irony, melting appeals, and electrifying eloquence" astonished and enthralled his audiences. As this daguerreotype suggests, Douglass's power was also rooted in the sheer impressiveness of his bearing, which abolitionist and activist Elizabeth Cady Stanton likened to that of "an African prince, majestic in his wrath." AMS

Frederick Douglass
(1818–1895)

Unidentified photographer
Sixth-plate daguerreotype, $3^1/_8$ x $2^{11}/_{16}$ ins
(8 x 6.9 cm), c. 1850 after c. 1847 original
NPG.80.21

Dolley Madison served as White House hostess during the administrations of the widowed Thomas Jefferson and her own husband, James Madison. Her effervescence doubtless accounted, in part at least, for the popularity of Madison's presidency in its last several years. After the end of Madison's term in 1817, Dolley helped her husband put his papers in order, selling a portion of them to Congress after his death.

William Elwell painted Dolley Madison's portrait in February 1848 and later sold it to her longtime friend William Winston Seaton, editor and co-owner of the Washington newspaper *The National Intelligencer*. The portrait offers a glimpse of the ageing Mrs. Madison, described by the artist in his diary as "a very Estimable lady—kind & obliging—one of the Old School." FSV

Dolley Madison
(1768–1849)

William S. Elwell (1810–1881)
Oil on canvas, $30^{1}/_4 \times 25^{1}/_4$ ins
(76.8 × 64.1 cm), 1848
NPG.74.6

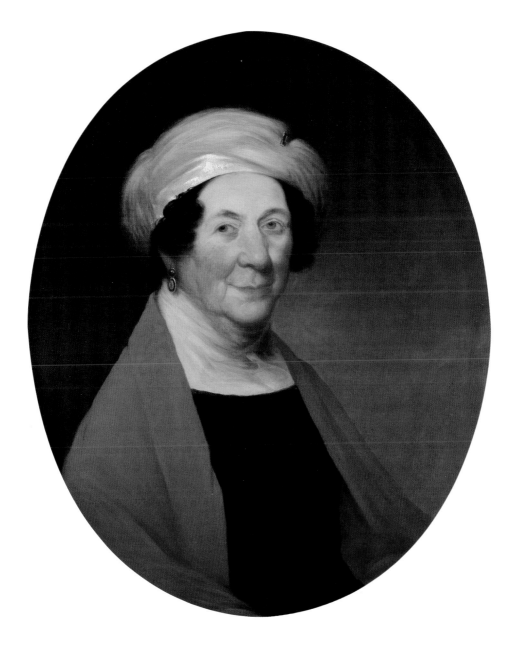

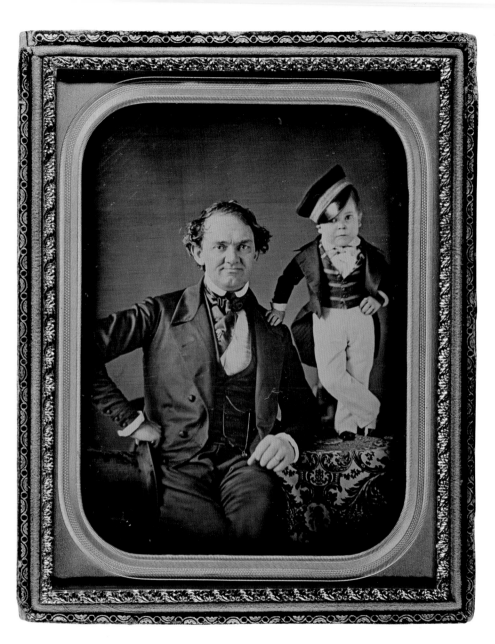

Showman P.T. Barnum was as skilled in promoting legitimate entertainment as he was in marketing outlandish frauds. In 1842, he scored one of his greatest triumphs when he discovered the diminutive Charles Stratton and introduced him to the public as "Tom Thumb." The four-year-old Stratton, who was just twenty-five inches tall and weighed only fifteen pounds, was transformed under Barnum's tutelage into a phenomenally popular entertainer who sang, danced, and performed a variety of costumed roles. Memorialized in this double portrait, the long-lived and amiable partnership between "Tom Thumb" and the "Prince of Humbug" generated substantial fortunes for both men. AMS

P.T. Barnum
(1810–1891) and
"Tom Thumb"
(1838–1883)

Attributed to Samuel Root (1819–1889) or
Marcus Aurelius Root (1808–1888)
Half-plate daguerreotype, 6 1/16 x 4 7/8 ins
(15.4 x 12.4 cm), c. 1850
NPG.93.154

Although scarcely more than twenty when he opened his first "daguerrean" gallery in New York City in 1844, Mathew Brady quickly earned accolades for his superior portraits. His clientele grew to include prominent men and women from every quarter, and his collection of images of the famous was soon unsurpassed. While daily studio operations remained the province of his camera operators and technicians, Brady provided the creative vision and marketing expertise that by the time of the Civil War made him the best-known photographer in America. This daguerreotype pictures Brady with his wife, Julia, and a Mrs. Haggerty, Brady's sister. AMS

Mathew Brady
(c. 1823–1896), Juliet ("Julia")
Handy Brady (1822–1887) and
Mrs. Haggerty (dates unknown)

Mathew Brady Studio (active 1844–1894)
Quarter-plate daguerreotype,
4³/₁₆ x 3¹/₄ ins (10.7 x 8.3 cm), c. 1851
NPG.85.78

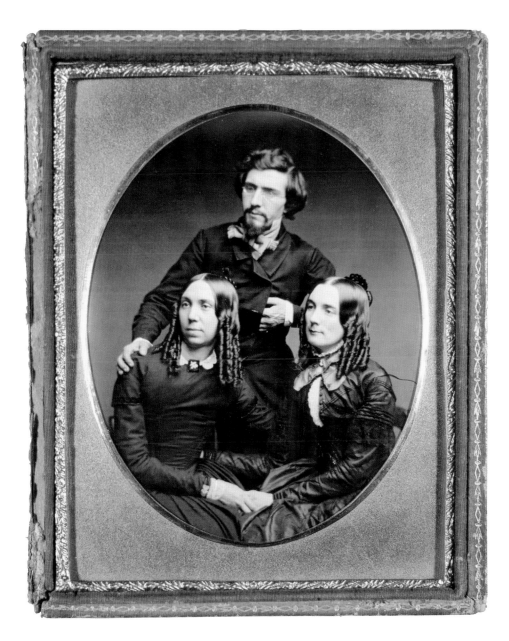

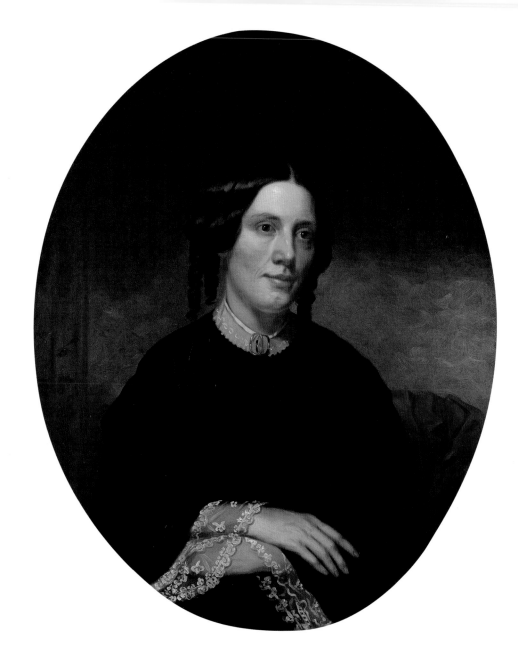

Excluded from public professions, cultivated women sought other avenues for their talents. From discussing the issues of the day in informal salon gatherings, it was a short step for women to become writers, especially since the antebellum period saw a burgeoning number of magazines catering to female concerns. So Harriet Beecher Stowe started a career that made her one of the most popular novelists of the nineteenth century. Stowe's place in American history was sealed with her novel *Uncle Tom's Cabin* (1851–52), which sold 300,000 copies in its first year. *Uncle Tom's Cabin* was a reform novel; Stowe was motivated to write it by the Fugitive Slave Law and the role of slavery in destroying the African American family. No more effective charge could be made in a nation that, both North and South, revered the family as the foundation of society. DCW

Harriet Beecher Stowe
(1811–1896)

Alanson Fisher (1807–1884)
Oil on canvas, 34 x 27 ins
(86.4 x 68.6 cm), 1853
NPG.68.1

Described by a contemporary as "the apostle of individuality in an age of association and compromise," the author Henry David Thoreau followed his own moral compass and lived a life largely unfettered by convention. In such works as *Walden* (1854) and *On the Duty of Civil Disobedience* (1849), Thoreau encouraged readers to question popular wisdom and to seek universal truths from simple facts. When an admirer wrote from Michigan in 1856 asking for Thoreau's daguerreotype and enclosing money to defray its cost, the author reluctantly obliged. A visit to Maxham's Daguerrean Palace yielded this 50-cent portrait, which Thoreau dutifully sent to the author of the request along with $1.70 in change. AMS

Henry David Thoreau
(1817–1862)

Benjamin D. Maxham (active 1848–1858)
Ninth-plate daguerreotype, $2^{1}/_{2}$ x $1^{7}/_{8}$ ins
(6.3 x 4.7 cm), 1856
Gift of an anonymous donor
NPG.72.119

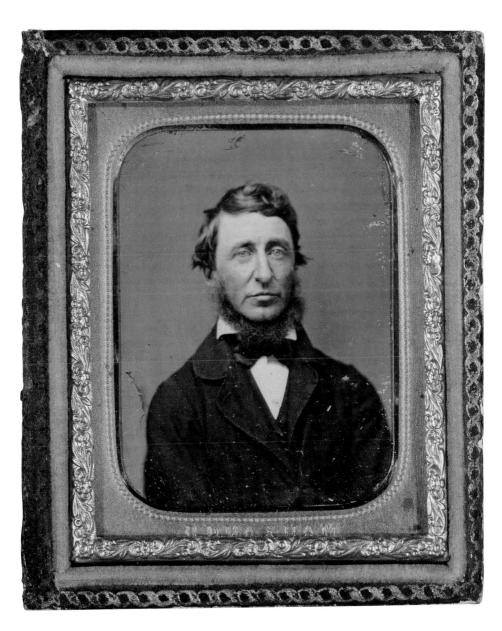

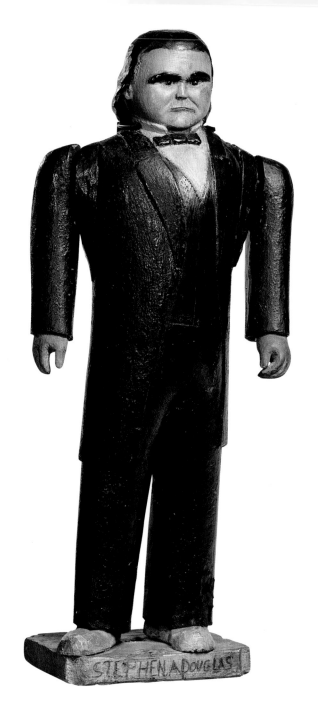

The national prominence of Illinois senator Stephen A. Douglas rested on his promotion of "popular sovereignty"—a doctrine devised in the early 1850s to permit settlers of new territories to decide for themselves whether or not to permit slaveholding. In his quest for the presidency in 1860, Douglas continued to urge this principle. By then, however, feelings on slavery in both North and South had been so radicalized that his position did not hold much appeal for either side. Although he was Abraham Lincoln's nearest rival in the four-way contest that year, his defeat was almost inevitable.

Douglas had faced Lincoln earlier, in 1858, when Lincoln unsuccessfully tried to take Douglas's U.S. Senate seat. This carving is thought to be a memento of that occasion. A contemporary once described Douglas as a "lively five-footer full of brains, bounce, and swagger." Despite its primitive aspect, the carving seems to bear out that description. JGB/FSV

Stephen A. Douglas
(1813–1861)

Unidentified artist
Painted wood, height 18¼ ins (46.4 cm),
c. 1858
Gift of Richard E. Guggenheim
NPG.71.59

George A. Custer graduated from the U.S. Military Academy in June 1861, two months after the beginning of the Civil War. He entered the war a second lieutenant in the Second Cavalry and was one of the Union's rising stars. Only two years later, at twenty-three, he became the youngest officer promoted to brigadier general. Before the war was over, he was a major general with two stars and was commanding the Third Division of Sheridan's cavalry corps. In the days just before the surrender of Robert E. Lee (see p. 94), Custer's men played a supporting role in blocking the enemy's retreat near Appomattox. JGB

George A. Custer
(1839–1876)

Unidentified photographer
Ambrotype, $4^1/_4 \times 3^1/_4$ ins
(10.8 x 8.3 cm), c. 1860
NPG.81.138

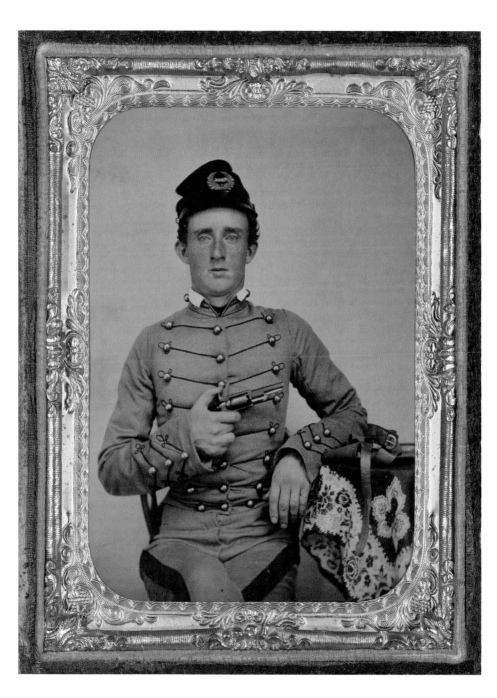

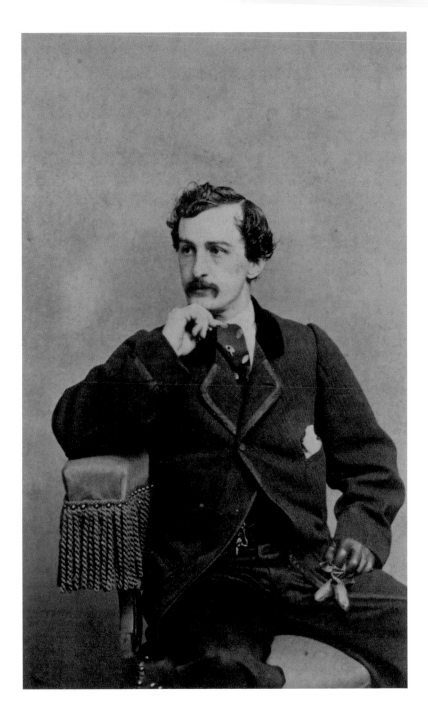

A member of one of America's most famous theatrical families, John Wilkes Booth was fiercely dedicated to the Confederate cause. By the final months of the Civil War, he had become obsessed with his deep hatred of President Lincoln. In late 1864, thinking that the southern cause could be salvaged with Lincoln out of the way, he conspired to kidnap the Union president and deliver him into Confederate hands in Richmond. After that scheme failed, he began plotting Lincoln's assassination. On the evening of April 14, 1865, his plan tragically unfolded when he fatally shot Lincoln as the president sat watching a play at Ford's Theatre in Washington. Booth fled across the Potomac river into Virginia—despite breaking his leg as he escaped from the theater—but was shot dead by police early the next morning.

Cartes de visite, such as this one of Booth, were popular and inexpensive souvenirs distributed by the actors themselves and collected by admirers at the time of the Civil War. JGB

John Wilkes Booth
(1838–1865)

Charles DeForest Fredricks (1823–1894)
Albumen silver print, 3⁹/₁₆ x 2¹/₈ ins
(9 x 5.4 cm), *c.* 1862
NPG.80.214

One of the enduring myths of America is that it has no history but exists in the liberating freedom of the present moment. Nathaniel Hawthorne's novels, fables, and "tales" were a cautionary lesson to Americans who ignored the past. (Hawthorne knew the more optimistic writers of the time but was friends with none of them.) His writings secularized the harsh Puritan worldview of his Salem birthplace to remind Americans that actions had consequences, for both individuals and communities. His novels turn on the clash of the individual will—from the lovers in *The Scarlet Letter* (1850) to the naïve philanthropist of *The Blithedale Romance* (1852)—against the implacability of society and nature. Hawthorne's sympathies are often with his rebels, but his philosophy requires their defeat. It was perhaps the irreconcilability of these viewpoints that led to his artistic decline in the 1850s. DCW

Nathaniel Hawthorne
(1804–1864)

Emanuel Gottlieb Leutze (1816–1868)
Oil on canvas, $29^7/_8 \times 25^1/_4$ ins
(75.9 × 64.1 cm), 1862
Gift of the A.W. Mellon Educational
and Charitable Trust
NPG.65.55

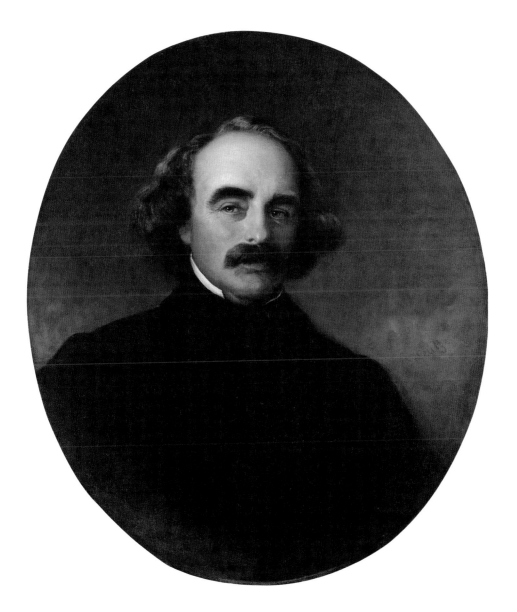

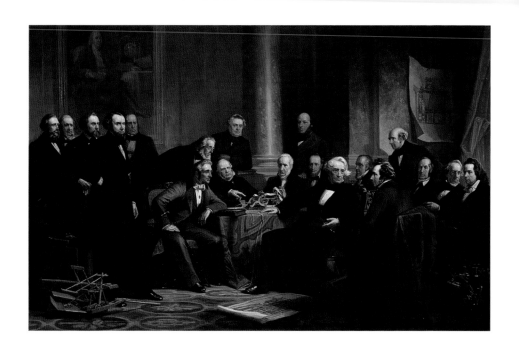

In 1857, the inventor of a coal-burning stove, Jordan Mott, commissioned Christian Schussele to paint a group portrait of eighteen American scientists and inventors who "had altered the course of contemporary civilization." As with Schussele's celebration of American letters, *Washington Irving and His Literary Friends at Sunnyside*, the group portrait did not mark an actual occasion but was designed to honor the achievements of American industry. The artist sketched study portraits of each of his subjects before putting them all into his final, formal composition. *Men of Progress* is a remarkable document of the growth of the American economy by the 1850s as it celebrates the inventions and processes of manufacturing pioneered by such men as Cyrus McCormick, Samuel Colt, and Elias Howe. DCW

Left to right
William T.G. Morton (1819–1868), James Bogardus (1800–1874), Samuel Colt (1814–1862), Cyrus McCormick (1809–1884), Joseph Saxton (1799–1873), Charles Goodyear (1800–1860), Peter Cooper (1791–1883), Jordan L. Mott (1799–1866), Joseph Henry (1797–1878), Eliphalet Nott (1773–1866), John Ericsson (1803–1889), Frederick E. Sickels (1818–1895), Samuel F.B. Morse (1791–1872), Henry Burden (1791–1871), Richard Hoe (1815–1884), Erastus B. Bigelow (1814–1879), Isaiah Jennings (1792–1862), Thomas Blanchard (1788–1864), Elias Howe (1819–1867)

Men of Progress

Christian Schussele (1824–1879)
Oil on canvas, 50$\frac{1}{2}$ x 75 ins
(128.3 x 190.5 cm), 1862
Gift of the A.W. Mellon Educational
and Charitable Trust
NPG.65.60

In the spring of 1861, Ulysses S. Grant hardly seemed destined for greatness. Having resigned his army captain's commission in 1854, this West Point graduate was eking out a living as a clerk. But the Civil War marked a dramatic shift in his fortunes. Reenlisting in the army, he was soon made a general. By war's end, he was commander of all Union land forces and, as the chief architect of the South's defeat, had become one of the country's heroes.

Grant's popularity led to his election to the presidency in 1868, but his weak control over his administration spawned an outbreak of federal corruption that made "Grantism" synonymous with public graft. Nevertheless, his charisma persisted through his two terms.

Mathew Brady photographed General Ulysses S. Grant at City Point, Virginia, in 1864. On June 19, Grant reported to his wife, "Brady is along with the Army and is taking a great many views and will send you a copy of each." FSV

Ulysses S. Grant
(1822–1885)

Mathew Brady (c. 1823–1896)
Albumen silver print, $4^9/_{16}$ x $4^3/_4$ ins
(11.6 x 12.1 cm), 1864
NPG.77.56

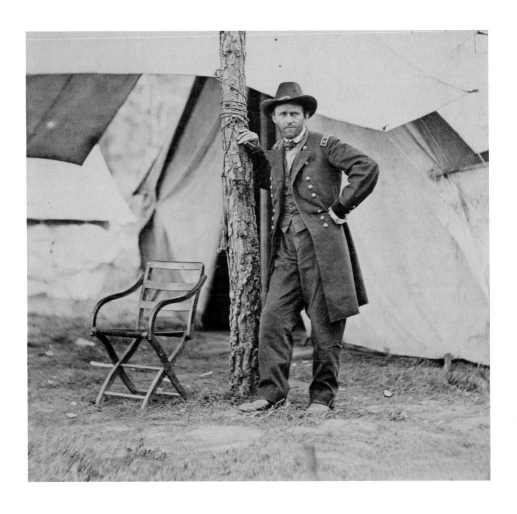

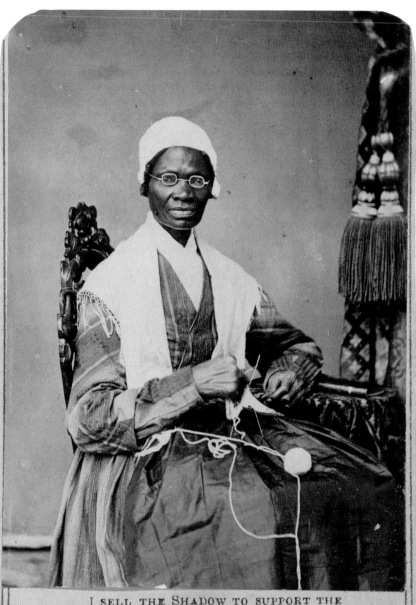

I SELL THE SHADOW TO SUPPORT THE
SUBSTANCE. SOJOURNER TRUTH.

In 1843, ex-slave Isabella van Wagener obeyed God's personal command to her, changed her name to Sojourner Truth, and became an itinerant preacher. Quickly becoming a major attraction on the revival circuit for the power and ingenuity of her prophetic speeches, she was drawn into abolitionism and entranced antislavery audiences with her personal testimony. Like Frederick Douglass (see p. 68), Truth was a charismatic figure because she was not a victim but a leader. She was also a powerful example of African American womanhood. As she concluded in a compelling oration on women's rights, "I could work as much … and bear the lash as well [as a man]—and aren't I a woman?" DCW

Sojourner Truth
(c. 1797–1883)

Unidentified artist
Albumen silver print, $3^1/_4 \times 2^1/_4$ ins
(8.3 × 5.7 cm), 1864
NPG.78.207

Robert E. Lee was born into a family prominent in Virginia society and politics. A young man with an intense desire to prove himself, he attained the highest rank available to cadets and graduated from West Point in 1829.

Initially, Lee opposed both secession and war. But when Virginia voted to secede from the Union, he resigned from the army and went to his native state's defense. Placed in command of the Army of Northern Virginia in June 1862, Lee gave the Confederacy moments of hope with several early victories. By 1864, however, time and resources were working against him, and in May, Ulysses S. Grant (see p. 90) became his last and fateful adversary.

This is one of six photographs that Mathew Brady took of Lee upon his return to his home in Richmond. The date was April 16, 1865, a week after Lee had surrendered to Grant at Appomattox. JGB

Robert E. Lee
(1807–1870)

Mathew Brady (*c.* 1823–1896)
Albumen silver print, 8 3/16 x 6 ins
(20.8 x 15.2 cm), 1865
NPG.78.243

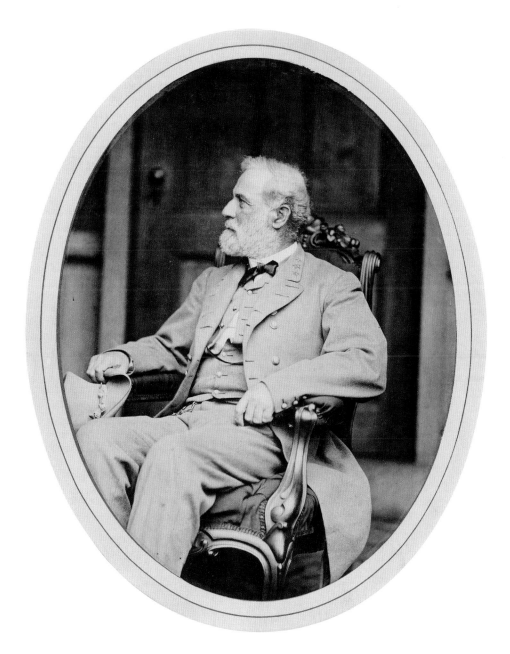

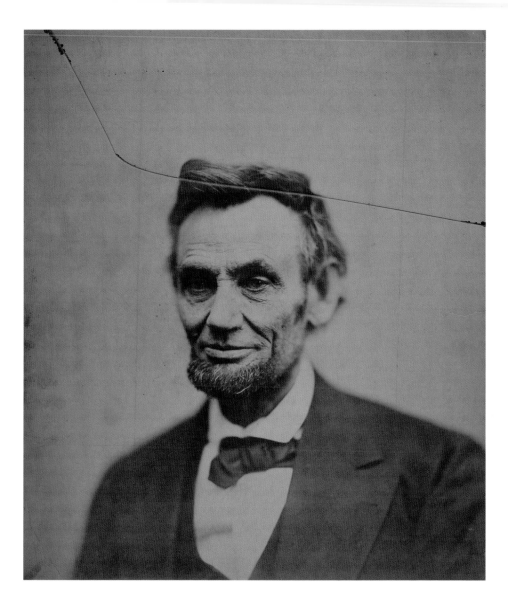

Lincoln's faint, tired smile in this likeness, taken a month before his second inauguration, makes it one of the most compelling photographic images ever taken of him. For many years, it was commonly thought that this photograph dated from early April 1865 and that it was the last one ever made of Lincoln. But in fact, it was part of a series of photographs taken at Alexander Gardner's Washington studio two months earlier, on February 5. In shooting the image, Gardner used a large glass negative, which broke before it could be processed. Nevertheless, he managed to make one print. Some have interpreted the crack running through the image as a portent of Lincoln's impending assassination. FSV

Abraham Lincoln
(1809–1865)

Alexander Gardner (1821–1882)
Albumen silver print, 17 $^{11}/_{16}$ x 15$^3/_{16}$ ins
(45 x 38.6 cm), 1865
NPG.81.M1

Today, Abraham Lincoln is universally regarded as one of our greatest presidents. But from the start of his administration, Lincoln, guiding the nation in a time of civil war, was beset with criticism from all sides. Some charged him with moral cowardice for initially insisting that an end to slavery was not one of his wartime goals; others accused him of overstepping his constitutional powers; still others blamed him for military reverses in the field. But as Union forces moved toward victory, Lincoln's eloquent articulation of the nation's ideals and his eventual call for an end to slavery gradually invested him with grandeur. Following his assassination in 1865, that grandeur became virtually unassailable.

The original version of this portrait was a template for George P.A. Healy's large painting *The Peacemakers*, depicting Lincoln in consultation with three of his main military advisers at the end of the Civil War. But Healy recognized that this made a fine portrait in its own right and eventually made three replicas, including this one. FSV

Abraham Lincoln
(1809–1865)

George Peter Alexander Healy (1813–1894)
Oil on canvas, 74¼ x 54 ins
(188.6 x 137.2 cm), 1887
Gift of the A.W. Mellon Educational
and Charitable Trust
NPG.65.50

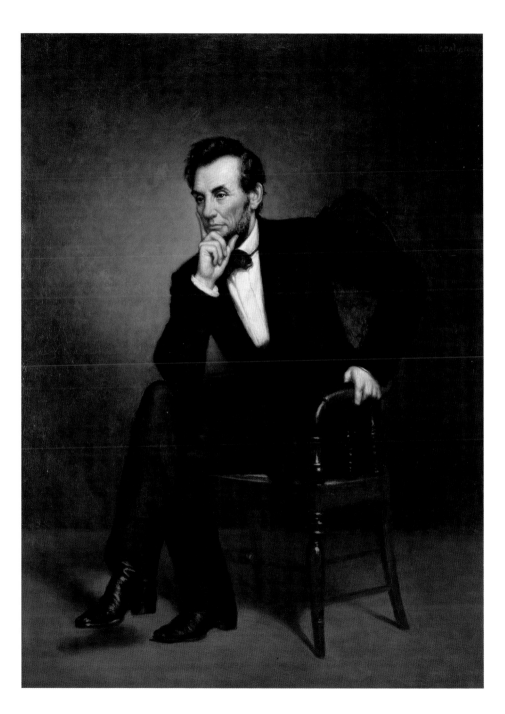

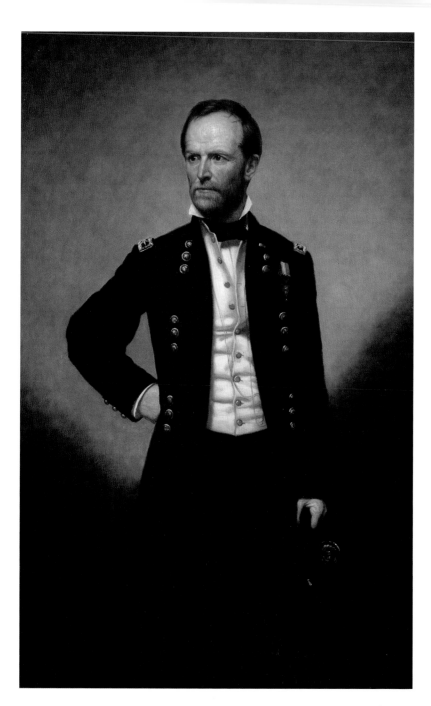

"War is war and not popularity-seeking." With these words to his Confederate opponent at Atlanta, General William T. Sherman suggested the attitude that made him both a successful commander and a bitterly hated figure in the South. He stripped war of glory and chivalry. His destructive march through Georgia and his later campaign in the Carolinas dismantled the economic base of the Confederacy and shattered the morale of its citizens. His methods anticipated twentieth-century "total war."

Influenced perhaps by Sherman's reputation for severe tactics in the field, the artist George P. A. Healy once noted that he found the Union general a forbidding portrait subject at first. But as the painting progressed, he found the general quite friendly. JGB

William T. Sherman
(1820–1891)

George Peter Alexander Healy (1813–1894)
Oil on canvas, 62½ x 37½ ins
(158.8 x 95.3 cm), 1866
Gift of P. Tecumseh Sherman
NPG.65.40

An actor turned inventor, Isaac Singer democratized clothing production with the sewing machine he patented in 1851. Although not the first (Elias Howe introduced a design in 1846), Singer's machine was more reliable and capable of continuous stitching. Hailed two years after its appearance as "one of the most efficient labor-saving devices ever introduced to public notice," Singer's machine could sew 900 stitches per minute, more than twenty times as many as a skilled seamstress. Aiming the product at women and putting it within reach of a wide range of buyers, Singer and his business partner Edward Clark established an international commercial empire.

Singer commissioned this portrait while living in Paris, after scandals about his private life forced him to relocate to Europe. The American artist Edward Harrison May painted him in clothing that reflects his wealth and trademark extravagance. MSS/ACG

Isaac Singer
(1811–1875)

Edward Harrison May (1824–1887)
Oil on canvas, 51½ x 38⅞ ins
(130.8 x 98.7 cm), 1869
Gift of the Singer Company
NPG.75.37

Before embarking on her celebrated writing career, Edith Newbold Jones Wharton led a privileged life as a member of New York society. Edward Harrison May, a British-born artist working in Paris, painted her portrait during an extensive family sojourn in Europe. Wharton, who would become famous for her critical depictions of the New York upper class, as in the Pulitzer Prize-winning *Age of Innocence* (1920), was strongly influenced by these European trips of her youth. As an adult she chose to spend much of her life abroad, forming friendships with other American expatriates, such as Henry James. Despite Wharton's cheerful demeanor in this portrait, she would later chronicle the frustrations of her childhood. Yet it was during this time that she came to enjoy "making up," occupying the fictional worlds she would write about as an adult. MSS/ACG

Edith Wharton
(1862–1937)

Edward Harrison May (1824–1887)
Oil on canvas, 28³/₄ x 23³/₄ ins
(73 x 60.3 cm), 1870
NPG.82.136

An innovative painter, designer, and printmaker, James Abbott McNeill Whistler frequently identified his landscapes and portraits as "symphonies," "nocturnes," and "arrangements," reflecting his interest in atmosphere, color, and line. Although often neglected in his native United States, Whistler was lionized by the avant-garde of Europe, and his most productive years were spent in London and Paris. The artist's wit, flamboyance, and love of controversy further heightened his celebrity.

Joseph Edgar Boehm sculpted this bust in 1872, the year in which Whistler exhibited his now-famous *Arrangement in Grey and Black: Portrait of the Artist's Mother* at the Royal Academy of Arts in London. ACG

James Abbott McNeill Whistler
(1834–1903)

Joseph Edgar Boehm (1834–1890)
Terra-cotta, height 27 ins (68.6 cm)
(with base), 1872
Bequest of Albert E. Gallatin
NPG.65.74

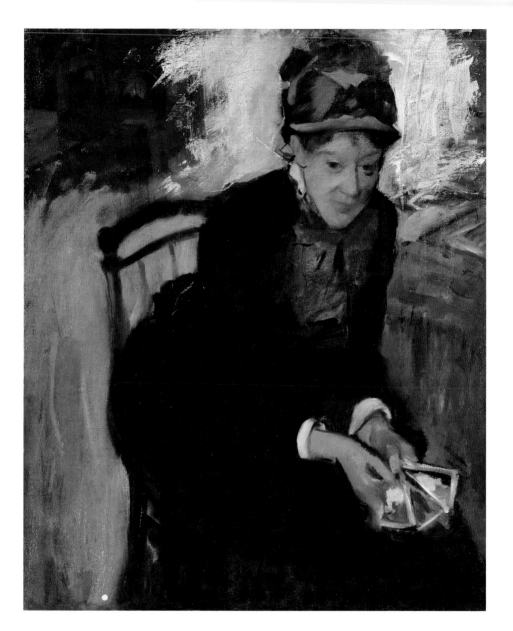

The American Impressionist Mary Cassatt spent her career in Europe, settling in Paris. Stifled by tradition, she regarded her exposure to the work of Edgar Degas in 1874 as a "turning point in my artistic life." After her rejection by the Paris Salon of 1877, Cassatt welcomed Degas's invitation to exhibit with the Impressionists in 1879. Cassatt shared their interest in the depiction of modern life and their commitment to developing innovative methods to capture fleeting moments. A lifelong friend of Degas, she served as model for him on a number of occasions. Despite her high regard for his work, Cassatt later dismissed this portrayal, commenting: "It has artistic qualities but is so painful and represents me as a person so repugnant that I would not wish it to be known that I posed for it." ACG

Mary Cassatt
(1844–1926)

Edgar Degas (1834–1917)
Oil on canvas, $28^7/8$ x $23^5/8$ ins
(73.3 x 60 cm), c. 1880–84
Gift of the Morris and Gwendolyn Cafritz
Foundation and the Regents' Major
Acquisitions Fund, Smithsonian
Institution
NPG.84.34

Elegantly depicted by the British artist Edward Hughes, Juliette Gordon Low radiates the luxury of her elite American birth and marriage to a wealthy Englishman. Low's satisfaction with her privileged lifestyle, however, soon faded. Following her unfaithful husband's death, she became interested in the Girl Guides, an organization established by her friend the British general Sir Robert Baden-Powell, who had also founded the Boy Scouts. Working with disadvantaged girls living near her Scottish estate, Low became a troop leader, imparting practical skills to her charges. After creating troops in London, she brought the idea to the United States, establishing a troop in her hometown of Savannah, Georgia. In 1915, Low incorporated the Girl Scouts of America. Today, the organization continues to inspire girls to pursue "the highest ideals of character, conduct, patriotism, and service that they may become happy and resourceful citizens." ACG

Juliette Gordon Low
(1860–1927)

Edward Hughes (1832–1908)
Oil on canvas, $52^1/_2$ x 38 ins
(133.4 x 96.5 cm), 1887
Gift of the Girl Scouts of the
United States of America
NPG.73.5

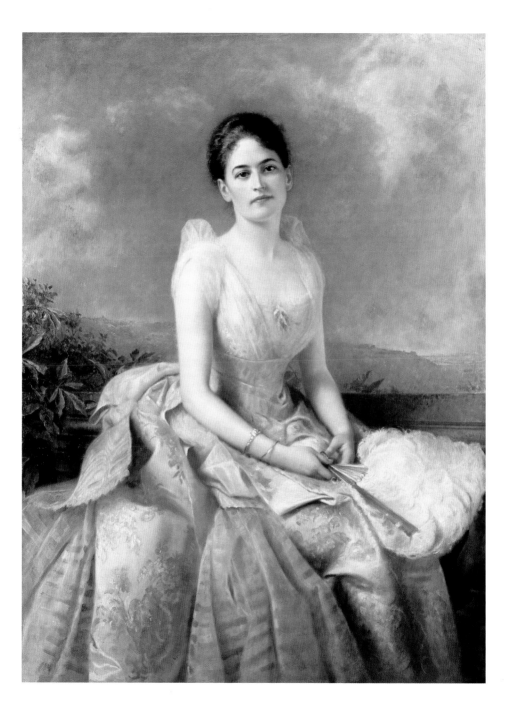

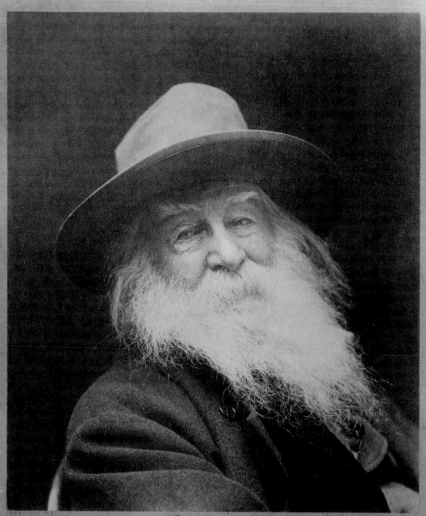

Walt Whitman
Sept: '87

Ralph Waldo Emerson wrote in 1844 that America had not found a poet worthy of the country's "ample geography" and "incomparable materials." But on July 4, 1855, Walt Whitman published *Leaves of Grass*, announcing himself as that writer. "I am the poet of the body/And I am the poet of the soul," he told Americans, proclaiming that he would encompass all of American nature and democracy by his celebration of the individual.

Whitman did not just celebrate; he created a new art form, structuring his ecstatic poems in long, overspilling lines to create a poetry that captured the expansiveness and vitality of America and its people. His romantic modernism created a means of self-expression that has influenced generations of artists, writers, and musicians.

Whitman admired the effect of this photograph by George Cox, calling it "The Laughing Philosopher." He sent a copy to Alfred, Lord Tennyson, poet laureate of England, who responded that he "liked it much—oh! so much." DCW

Walt Whitman
(1819–1892)

George C. Cox (1851–1902)
Platinum print, $8^{11}/_{16}$ x $7^{1}/_{4}$ ins
(22.1 cm x 18.4 cm), 1887
Gift of Mr. and Mrs. Charles Feinberg
NPG.76.98

Painted during Thomas Alva Edison's visit to Paris for the Exposition Universelle of 1889, Abraham A. Anderson's portrait depicts the wealthy entrepreneur at the height of his career. World-renowned for his inventions—including the phonograph, incandescent lamp, and movie camera—Edison, who received numerous honors in Europe, presided over one of the most popular exhibitions at the Exposition. Particularly intriguing to audiences was Edison's phonograph, the recent improvement of which Anderson chose to picture. Although Edison patented the device in 1877, earning himself the title of the "Wizard of Menlo Park," eleven years passed before he achieved sufficient clarity of sound to make it commercially viable. Using the word "specie" as a test, Edison labored until it could be properly transmitted. "When that was done," he reported, "I knew everything else could be done, which was a fact." ACG

Thomas Edison
(1847–1931)

Abraham A. Anderson (1847–1940)
Oil on canvas, 45 x 54^5/$_8$ ins
(114.3 x 138.7 cm), 1890
Gift of Eleanor A. Campbell
NPG.65.23

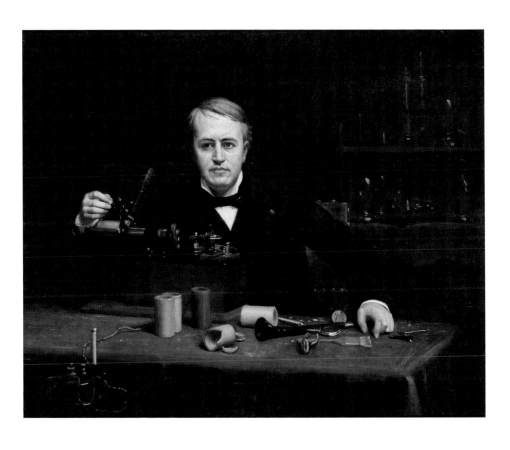

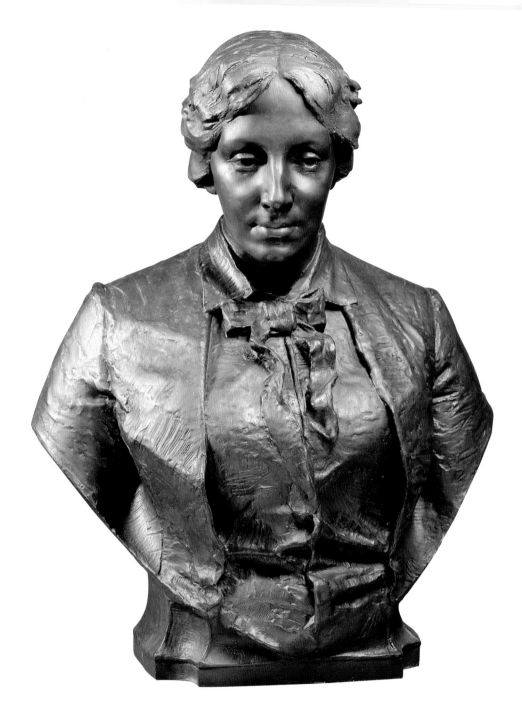

Louisa May Alcott began to write professionally in her teens when the impractical idealism of her father, the utopian theorist Bronson Alcott, put the family in dire financial straits. She published her first book, *Flower Fables*, in 1854. After serving as a nurse during the Civil War, she produced the memoir *Hospital Sketches* in 1863. Asked by her publisher to write a book for girls, Alcott drew upon her own family experiences to write *Little Women* (1868). This heartwarming novel, chronicling the lives of the four March sisters—Meg, Jo, Beth, and Amy—was a success at its publication and remains an American literary classic. AEH

Louisa May Alcott
(1832–1888)

Frank Edwin Elwell (1858–1922)
Bronze, height 28½ ins (72.4 cm), 1967
cast after 1891 plaster
Gift in memory of Alcott Farrar Elwell
(1886–1962) by his wife, Helen Chaffee Elwell
NPG.68.5

The American Loïe Fuller burst onto Paris's theatrical scene in 1893 with her groundbreaking serpentine dance. Born Mary Louise Fuller, she began on stage as a child, gaining some success in her teenage years as an actress, singer, dancer, and temperance lecturer. Her career took off when she created a dance that combined the grace of ballet with the technical innovation of electric lighting. The swirling fabrics and bright colors of her performance appealed to the young artists of her adopted country.

Fuller chose Jules Chéret to create this poster advertising her sensationally popular appearances at the Folies-Bergère. A pioneer of the color lithographic poster, Chéret was known for his brilliant hues, described by one critic as "a hooray of reds, a hallelujah of yellows, and a primal scream of blues." His rendition of Fuller inspired other artists to follow suit. MSS/ACG

Loïe Fuller
(1862–1928)

Jules Chéret (1836–1932)
Color lithographic poster, 43³/₄ × 32⁷/₁₆ ins
(111.1 × 82.4 cm), 1893
NPG.84.109

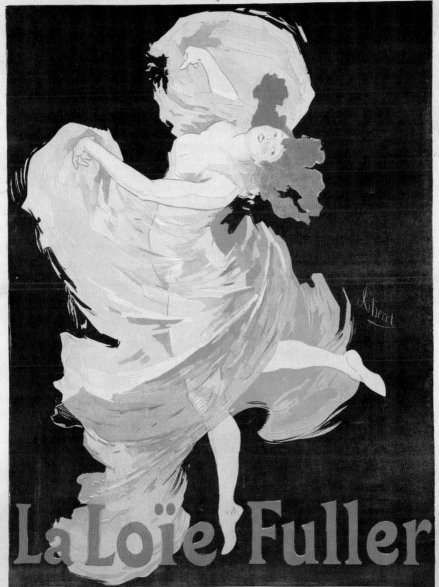

The Portraits:
1900–Present

William Cody arguably did more than any single American to popularize the myth of the American West. Before achieving international fame as a showman, he worked in a variety of short-term jobs, including Pony Express rider, army scout, and hunting guide. Having earned his nickname because of his prowess hunting buffalo, Cody entered the world of entertainment after a dime novelist in New York wrote a story about his exploits in the West. A subsequent offer to appear on stage led first to a theatrical career and ultimately to the creation in 1882 of his touring Buffalo Bill Wild West Show. For the next thirty years he was the centerpiece of this wildly popular display, which combined rodeo and historical reenactment. Colorful posters such as this did much to advertise his show and to enhance his larger-than-life reputation. FHG

William "Buffalo Bill" Cody
(1846–1917)

Courier Lithography Company
(active *c*. 1882–1905)
Color lithographic poster, 26½ x 40⁹⁄₁₆ ins
(67.3 x 103.1 cm), 1900
NPG.87.55

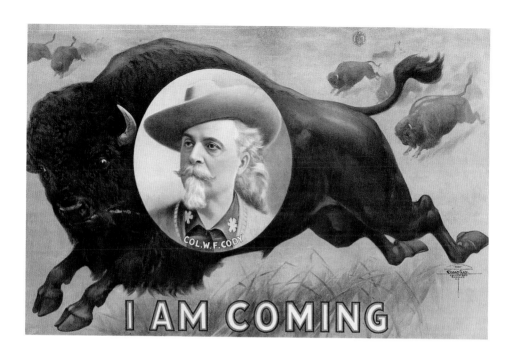

COL. W. F. CODY

I AM COMING

Accustomed to living abroad since childhood, master novelist Henry James was more comfortable in Europe than in the United States. James frequently pursued the theme of encounters between the Old World and the New in his fiction, and his books often explored the plight of Americans who lose their naïveté through adventures on the Continent. Although James ultimately claimed British citizenship, he never lost his sense of American identity. A close friend of the American novelist Edith Wharton (see p. 104), James was visiting her in France when he agreed to sit for this portrait by Jacques-Émile Blanche. Pleased with the final product, which disguised his girth, James declared that "it has a certain dignity of intention and indication—of who and what, poor creature, he 'is'! It ought to be seen in the U.S." ACG

Henry James
(1843–1916)

Jacques-Émile Blanche (1861–1942)
Oil on canvas, 39$\frac{1}{4}$ x 31$\frac{3}{4}$ ins
(99.7 x 80.6 cm), 1908
Bequest of Mrs. Katherine Dexter McCormick
NPG.68.13

Like his fellow industrialist Andrew Carnegie, Henry Clay Frick grew up
in a family of limited means. Yet by the age of thirty he had made his first
million dollars and had positioned himself as a key player in America's
industrial development. Believing that steel would be the principal building
material of the future, Frick amassed his fortune first by supplying coke—
fuel made from coal—to the steel industry and later by going into partnership
with Carnegie to create the world's largest steel company. A cutthroat
businessman who opposed labor unions, Frick was aggressive in making
his operations more efficient. In 1892, during a violent confrontation with
striking steelworkers in Homestead, Pennsylvania, he did not hesitate to
call in guards from the Pinkerton Detective Agency and the state militia
to break the union's resolve. This double portrait shows the industrialist
with his daughter Helen. FHG

Henry Clay Frick
(1849–1919) with Helen Frick

Edmund C. Tarbell (1862–1938)
Oil on canvas, 31 x 23 ins
(78.7 x 59.1 cm), *c.* 1910
NPG.81.121

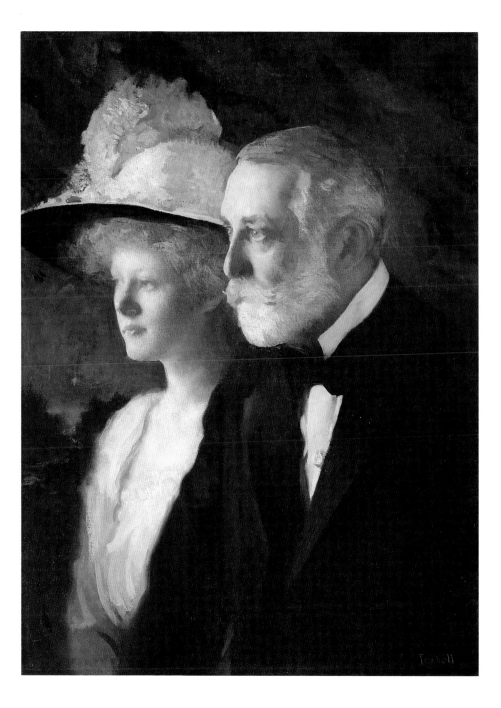

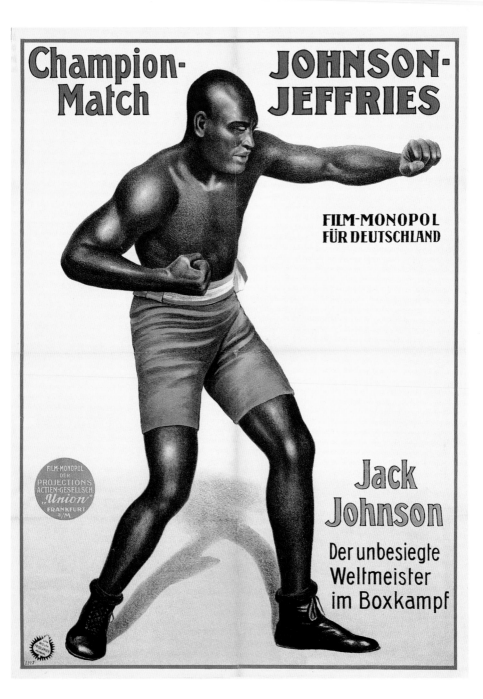

This German poster portrays Jack Johnson, the first black world heavyweight boxing champion, as a dignified athlete of magnificent physique. Advertising a film of his 1910 fight with Jim Jeffries, the image avoids the controversies the bout caused in the United States. Social reformers, who viewed the sport as barbaric, were successful in moving the event from San Francisco to Reno. The match, pitting "the Negroes' Deliverer" against the "Hope of the White Race," engendered bitter racial overtones. Upsetting notions of white racial superiority, Johnson's decisive victory caused race riots around the country, and the film was banned in many American cities. Without reference to such tensions, the poster, produced by a Hamburg company known for its circus advertising, heralds the emergence of sporting events as a major entertainment industry in twentieth-century global culture. WWR

Jack Johnson
(1878–1946)

Adolph Friedländer Lithography Company (active 1872–1938)
Color lithographic poster, $33^3/4 \times 22^3/4$ ins (85.7×57.8 cm), c. 1910
NPG.89.27

Using the pen name Mark Twain, Samuel Clemens had become one of this country's favorite satiric writers by the early 1870s, routinely making light of everyday human foibles. But it was the publication of *The Adventures of Tom Sawyer* (1876) and *The Adventures of Huckleberry Finn* (1884) that assured him a lasting place in American letters. Inspired in part by his own boyhood, these two tales set along the Mississippi River did more than capture the rhythms of youth in antebellum America. In both novels, Clemens examined with sardonic wit various tensions that underlay contemporary society, including, most importantly, the question of race. In later years, his success in this country and abroad was tempered by financial and personal setbacks and by a contempt for American and British imperialism. FHG

Samuel L. Clemens
(1835–1910)

John White Alexander (1856–1915)
Oil on canvas, 75³/₄ × 36¹/₄ ins
(192.4 × 92.1 cm), *c.* 1912
NPG.81.116

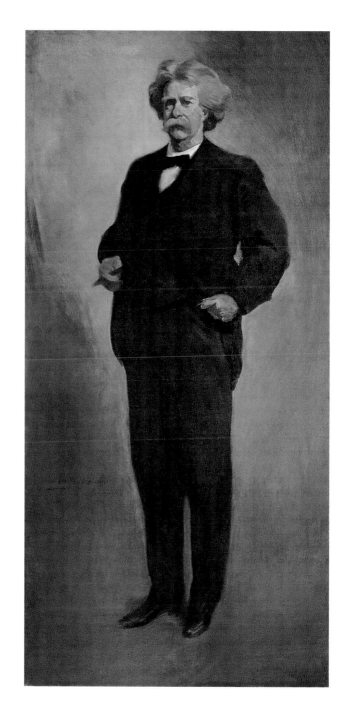

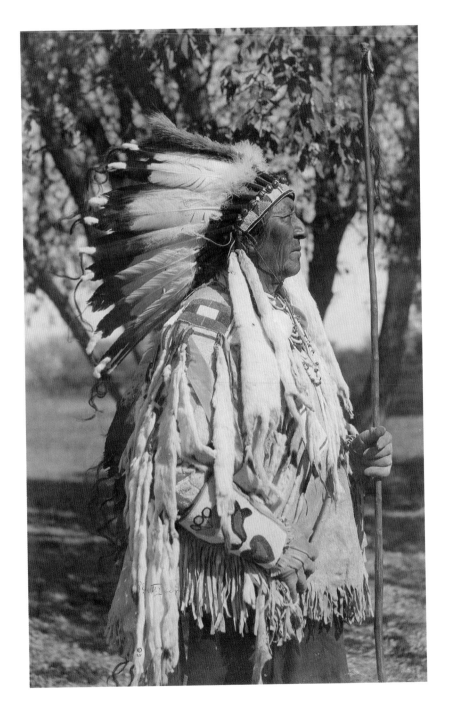

A celebrated warrior as a young man, Plenty Coups played a crucial role in leading the Crow during the difficult transition to reservation life. Not unlike his near-contemporary Booker T. Washington, he stressed the importance of education as a means to maintain tribal integrity and urged his people to become self-sufficient farmers. Although Plenty Coups became a Catholic, he revered and sought to carry on the Crow people's native religion and traditional folkways. Dressed in ceremonial regalia, Plenty Coups is thought to have posed for this photograph at the outset of his 1921 trip to Washington, D.C., where he served as the Native American representative at the burial of the unknown soldier of World War I at Arlington National Cemetery. Three years later, in part because of the Native American contribution to the war effort, the landmark Indian Citizenship Act was passed. FHG

Plenty Coups
(c. 1848–1932)

Willem Wildschut (1883–1955)
Gelatin silver print, 36 x 24 ins
(91.4 x 61 cm), c. 1921
Gift of the Ruth and Vernon Taylor
Foundation, Beatrice and James Taylor
NPG.2004.128

On April 15, 1920, two gunmen took the payroll and killed the paymaster and guard of the Slater & Morrill shoe factory in South Braintree, Massachusetts. The police charged two Italian immigrants, Nicola Sacco (right) and Bartolomeo Vanzetti, members of a violent anarchist organization, with the crime. The district attorney denounced them not only as murderers, but also as foreign anarchists and atheists; some believe he even intimidated witnesses and falsified evidence. When the pair were found guilty and sentenced to death, many attributed the verdict to the "Red Scare," in which suspected radicals were arrested. Despite worldwide protests, eight motions for a new trial, and the appointment of a commission to review the case, both men were electrocuted. Historians disagree on whether these men were martyrs or were guilty. A news photographer took this shot in the courtroom while the manacled pair awaited sentencing. SH

Nicola Sacco
(1891–1927) and
Bartolomeo Vanzetti
(1888–1927)

Unidentified photographer
Gelatin silver print, 5¼ x 9½ ins
(13.3 x 24.1 cm), 1921
NPG.80.293

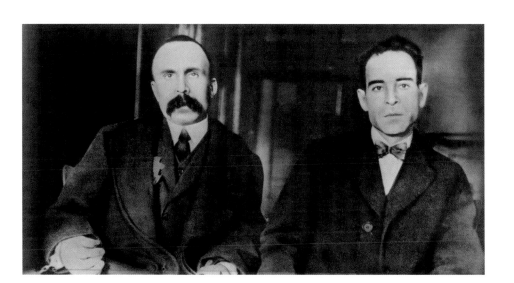

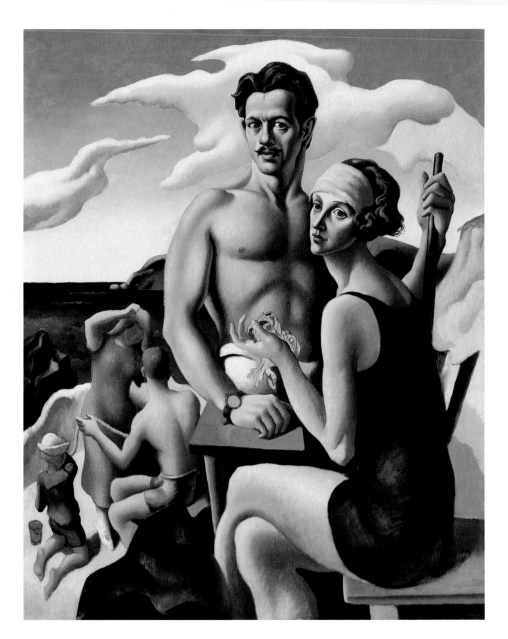

In the early years of his career, Thomas Hart Benton was among the young painters drawn to abstraction. He soon rejected that brand of modernism, however, and emerged in the 1920s as a leader of the regionalist school of realism, whose primary concern was the portrayal of local life and history in America. Best known for his panoramic murals, Benton brought to his works a boldness of composition that led one critic to describe him as "the most ... vigorous and virile of our painters." Benton made this portrait of himself and his wife at Martha's Vineyard in Massachusetts during the first year of their marriage. In the course of their residence there, he later recalled, "I really began to mature my painting," and the monumentality of its muscular figures anticipates his later work. WWR

Thomas Hart Benton
(1889–1975) with his wife Rita

Self-portrait
Oil on canvas, 49 x 39 3/8 ins
(124.5 x 100 cm), 1922
Gift of Mr. and Mrs. Jack H. Mooney
NPG.75.30

The American expatriate writer Gertrude Stein was a high priestess of
early twentieth-century modernism for the many who visited her fabled
Paris apartment. She collected and promoted the art of the avant-garde,
including that of Picasso and Matisse, and her own abstract, repetitive prose
inspired the experiments of playwrights, composers, poets, and painters.
"There was an eternal quality about her," the sculptor Jo Davidson wrote.
"She somehow symbolized wisdom." He chose to depict her here as "a sort
of modern Buddha." Delighted by the sculpture, Stein composed one of
her famous prose portraits of Davidson, later published in *Vanity Fair*
alongside a photograph of this work. WWR

Gertrude Stein
(1874–1946)

Jo Davidson (1883–1952)
Terra-cotta, height 30 ins (76.2 cm)
(with base), 1922–23
Gift of Dr. Maury Leibovitz
NPG.78.196

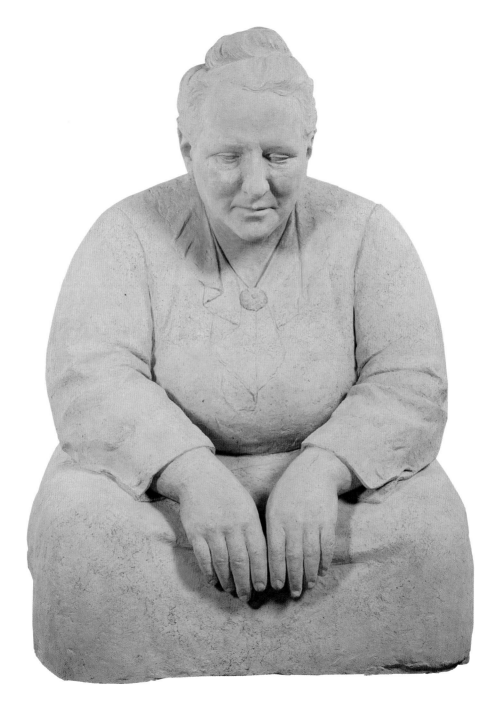

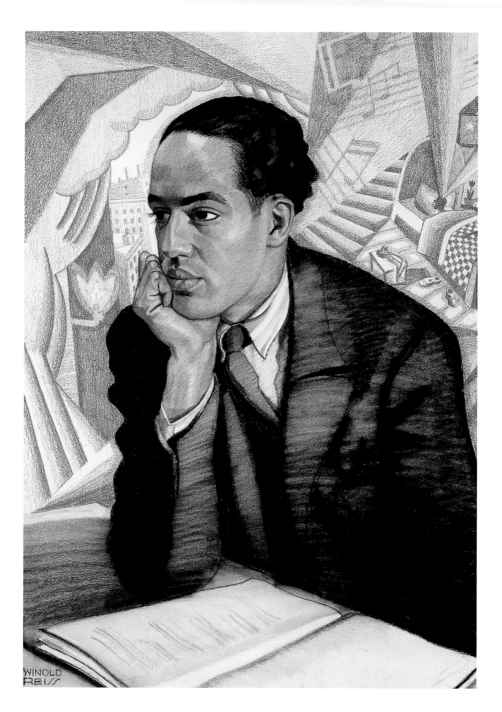

Langston Hughes published his first poem before he left high school, and in 1926, at the age of twenty-four, he achieved national prominence with the publication of his first volume of verse, *The Weary Blues*. Hughes was one of the most prolific and versatile writers of the 1920s Harlem Renaissance, a movement that recognized and celebrated the creative efforts of black artists, singers, composers, and writers. He was sometimes faulted for dwelling on the negative aspects of the African American experience in his poems, short stories, and novels. Still, while his work reflected his radical agenda for change, it also radiated a transcendent pride in his heritage.

The German-born artist Winold Reiss, who did a series of large pastels of famous black intellectuals and artists of the era, suggested Hughes's introspective imagination through the pose and background of this portrait. FSV/WWR

Langston Hughes
(1902–1967)

Winold Reiss (1886–1953)
Pastel on illustration board, 30 1/16 x 21 5/8 ins
(76.3 x 54.9 cm), 1925
Gift of W. Tjark Reiss, in memory
of his father, Winold Reiss
NPG.72.82

Author of more than a dozen volumes of verse, Marianne Moore received virtually every major literary award—including the Pulitzer Prize and the National Book Award—that the United States had to offer. Moore was acclaimed by her contemporaries, including T.S. Eliot, who cited the "original sensibility and alert intelligence" of her poetry. Using unconventional metrical schemes and focusing on such no-nonsense virtues as courage, loyalty, and patience, her innovative and exquisitely crafted verse secured her a leading position among modernist writers.

This portrait—*Marianne Moore and Her Mother*—by Marguerite Zorach, rich with the bright fauvist colors and faceted cubist planes that the artist picked up from four years in Paris, records Moore at an important moment in her rise to fame. It suggests the influence of Moore's mother, who lived with her daughter and edited her poetry, as well as the red-haired dynamism of Moore herself. WWR

Marianne Moore
(1887–1972)

Marguerite Zorach (1887–1968)
Oil on canvas, 40$^1/_4$ x 30$^1/_2$ ins
(102.2 x 77.5 cm), 1925
NPG.87.217
© Estate of Marguerite Thompson Zorach

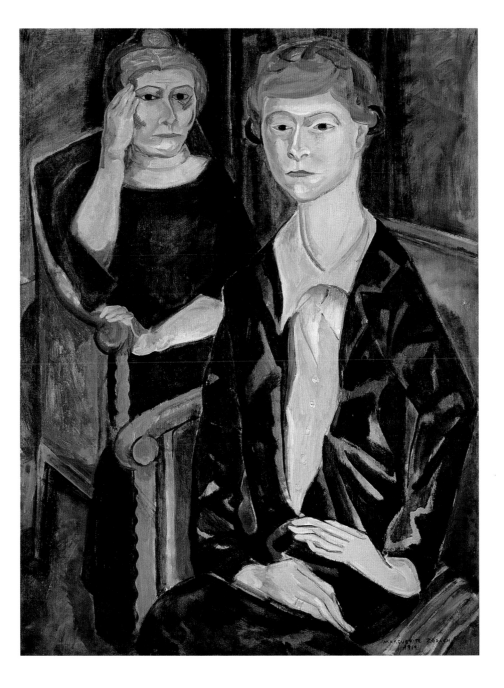

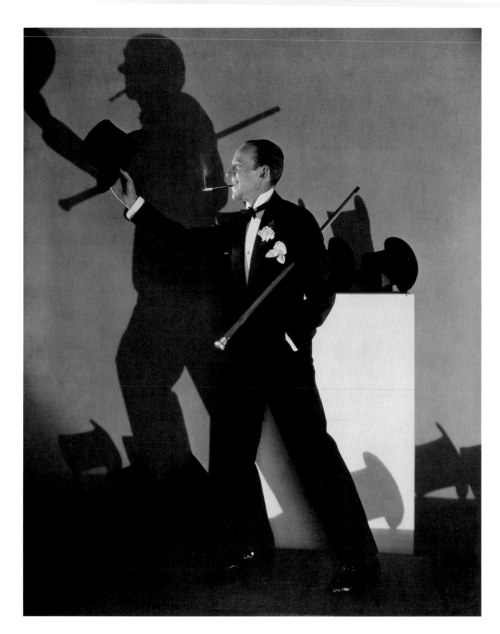

When Edward Steichen took this picture in 1927 for *Vanity Fair*, the dancer-actor Fred Astaire was starring on Broadway in *Funny Face* and was well established as musical theater's "fleetest of jazz steppers." But Astaire achieved his greatest fame in the 1930s, when he went to Hollywood to make movie musicals and teamed up with Ginger Rogers. Starring together in such films as *Flying Down to Rio* (1933), *The Gay Divorcee* (1934), and *Top Hat* (1935), Astaire and Rogers brought a romantic glamour to their films that was uniquely their own, and their on-screen elegance provided moviegoers with a much-welcomed escape from the gray realities of the Depression. Astaire had a genius for making his dancing seem effortless, but behind the finished performance, he said, were long days of experimenting that often produced "nothing but exhaustion." FSV

Fred Astaire
(1899–1987)

Edward Steichen (1879–1973)
Gelatin silver print, 9½ x 7⅝ ins
(24.2 x 19.3 cm), 1927
Acquired in memory of Agnes and Eugene Meyer through the generosity of Katharine Graham and the New York Community Trust, The Island Fund; NPG.2001.15
Permission of Joanna T. Steichen; © The Estate of Edward Steichen, represented by Howard Greenberg Gallery

On May 20, 1927, Charles Lindbergh took off from New York in his single-engine plane, *The Spirit of St. Louis*. He landed thirty-six hours later in Paris and was greeted by 100,000 wildly cheering Frenchmen. The shy Lindbergh brought letters of introduction to claim his prize for the first solo nonstop flight from New York to Paris. His instant fame in Europe grew into tumultuous celebrations in the United States, where millions cheered him, and he was awarded the Congressional Medal of Honor. So began America's infatuation with "Lucky Lindy." Later, in the dark days before World War II, Lindbergh's admiration for German efficiency and industry, and his campaign against America's entry into the war, could not fully dim his luster. The "lone eagle's" battle with the elements and the machine struck a chord in America's psyche that still reverberates today. SH

Charles Lindbergh
(1902–1974)

Unidentified photographer
Gelatin silver print, 9³/₁₆ x 7⁵/₁₆ ins
(23.3 x 18.5 cm), 1927
NPG.80.243

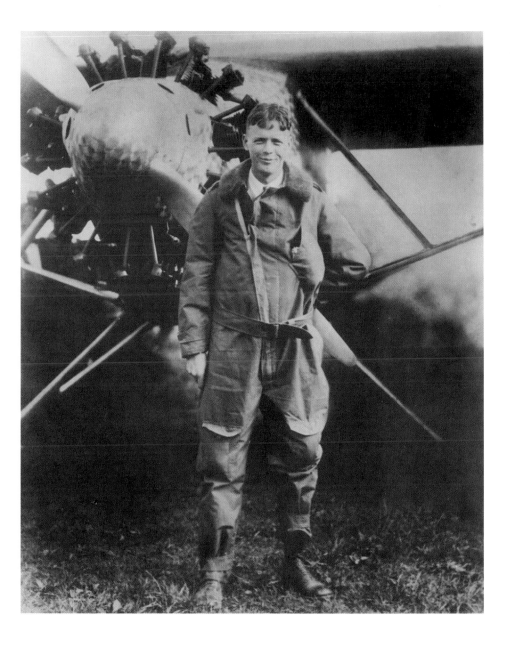

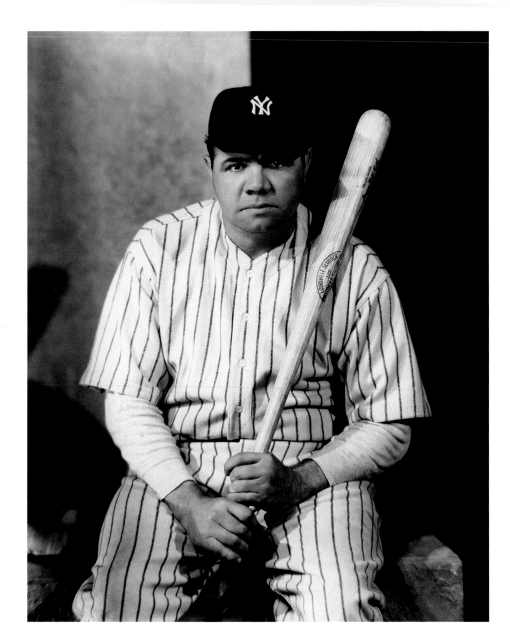

Signed by the Boston Red Sox in 1914, the muscular, six-foot two-inch, 150-pound "Babe" (George Herman) Ruth was a gifted pitcher who helped the Sox win championships, but in 1919 he shifted to the outfield to utilize his even more impressive skills as a fielder and batter. The next year, the Yankees paid the Sox $125,000 for Ruth, an enormous sum for the time. In his first year as a Yankee, Ruth hit an astonishing fifty-four home runs, more than any *team* in the American League. In 1923—the first season played in Yankee Stadium ("The House That Ruth Built")—he had what he regarded as his best year and led the Yankees to their first of many World Series victories with three homers and a .368 batting average. Ruth's home-run records have been eclipsed, but many view him as the greatest ever to play the game. SH

Babe Ruth
(1895–1948)

Nickolas Muray (1892–1965)
Gelatin silver print, $9^5/8 \times 7^{11}/_{16}$ ins
(24.5 × 19.5 cm), 1927 (printed 1978)
NPG.78.150
© Nickolas Muray Photo Archives

In 1954, when Ernest Hemingway received the Nobel Prize for Literature, the committee cited his "mastery of the art of modern narration." In fact, in his short stories and such novels as *The Sun Also Rises* (1926) and *For Whom the Bell Tolls* (1940), Hemingway had in large measure invented a new literary style as he chronicled the disillusionment of a post-World War I "lost generation." His terse, powerful prose became a major influence on American literature. Hemingway's own experiences—reporting foreign wars, living the bohemian life in Paris, and adventuring in Africa, Spain, or Cuba—fueled his imagination and helped create his larger-than-life persona. Man Ray's 1928 photograph of a bandaged Hemingway, made after an accident with an overhead window, occasioned the quip from the poet Ezra Pound: "How the hellsufferin tomcats did you git drunk enough to fall upwards through the blithering skylight!" WWR

Ernest Hemingway
(1899–1961)

Man Ray (1890–1976)
Gelatin silver print, 8 7/8 x 6 7/8 ins
(22.5 x 17.5 cm), 1928
NPG.77.130
© 2000 Man Ray Trust/Artists Rights
Society (ARS), NY/ADAGP, Paris

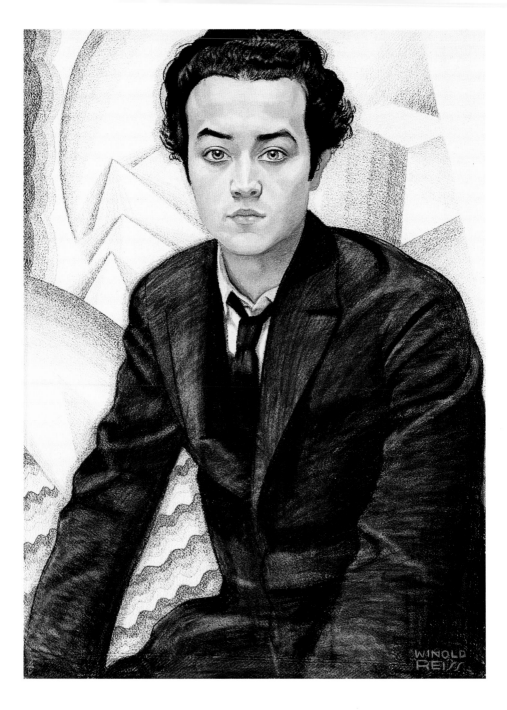

WINOLD
REISS

The German-born artist Winold Reiss challenged the racial typing of minorities by portraying his black, Native American, and Asian subjects as dignified individuals. His portrait of the sculptor Isamu Noguchi defied the "yellow peril" stereotyping that followed the 1924 National Origins Act banning Chinese and Japanese immigration. With his frontal pose and bold, confrontational gaze, Noguchi, whose father was Japanese, appears as a self-assured, thoroughly modern young American. The abstract background hints at that mix of the organic and geometric that characterizes Noguchi's sculpture. At the time, Noguchi had just returned from Paris on a Guggenheim Fellowship. In his grant application, he had stated how he planned to reconcile his dual ethnicity through art: "My father ... has long been known as an interpreter of the East to the West, through poetry. I wish to do the same with sculpture." WWR

Isamu Noguchi
(1904–1988)

Winold Reiss (1886–1953)
Pastel on paper, 29 x 21½ ins
(73.7 x 54.6 cm), c. 1929
Gift of Joseph and Rosalyn Newman
NPG.86.226

During the 1920s and 1930s, the glamorous husband-and-wife team of Ely and Josephine Culbertson succeeded in transforming bridge from a parlor game into an international phenomenon. Already accomplished players when they married in 1923, the duo enjoyed spectacular success on the tournament circuit with their unconventional bidding methods and playing strategies pioneered by Ely. When contract bridge was introduced in 1926, Ely seized the opportunity to establish himself as the new game's foremost expert and practitioner. After launching *The Bridge World* magazine in 1929 and publishing his best-selling *Contract Bridge Blue Book* the following year, Culbertson partnered with his wife to score victories in a series of high-profile matches at home and abroad. The unprecedented media coverage of these contests made the Culbertsons international celebrities and ignited a contract bridge craze that remained unabated for more than a decade. AMS

Ely Culbertson
(1891–1955) and
Josephine Dillon Culbertson
(1898–1956)

Nikol Schattenstein (1877–1954)
Oil on canvas, 50 x 40¼ ins
(127 x 102.3 cm), c. 1930
NPG.90.42

Renowned for her sultry voice and languorous sophistication, the actress Tallulah Bankhead exuded magnetism—"a remarkable personality with a remarkable name" to one enchanted critic. She performed not only in America but also in London, where she was painted by Augustus John: "At the time, I was the toast of London and that was some toast, dahling." She twice won the New York Drama Critics Award, as Regina in *The Little Foxes* in 1939 and as Sabina in *The Skin of Our Teeth* in 1942. Bankhead also starred in movies—notably Alfred Hitchcock's *Lifeboat* in 1944—and on television, where she hosted NBC's Sunday-night *Big Show* and appeared on that network's *All Star Revue*. At the height of her career in the late 1940s, *Time* magazine called her "the theater's first personality." AEH

Tallulah Bankhead
(1902–1968)

Augustus John (1878–1961)
Oil on canvas, 48³/₄ x 24³/₄ ins
(123.8 x 62.9 cm), 1930
Gift of the Honorable and Mrs. John
Hay Whitney
NPG.69.46
© Estate of Augustus John

In the long struggle for civil rights and racial equality in America, few episodes had the impact of the infamous Scottsboro Boys case. When nine black teenagers falsely accused of raping two women on a freight train were tried in Scottsboro, Alabama, in 1931, white juries found eight of the nine guilty, and they were sentenced to death. The widely condemned verdicts and the subsequent reversals, retrials, and hearings mobilized protests across the country and around the world.

In this pastel, Aaron Douglas, the leading visual artist of the Harlem Renaissance, portrayed Clarence Norris (left) and Haywood Patterson, whose convictions had been unanimously overturned by the U.S. Supreme Court because of Alabama's exclusion of blacks from the jury rolls. Focusing on the essential humanity and dignity of the subjects, Douglas's moving portrait suggests his profound response to this soul-chilling miscarriage of justice. WWR

The Scottsboro Boys
Clarence Norris (1912–1989) and Haywood Patterson (1913–1952)

Aaron Douglas (1899–1979)
Pastel on paper, 16⅛ x 14⅝ ins
(41.0 x 37.1 cm), c. 1935
NPG.2004.6

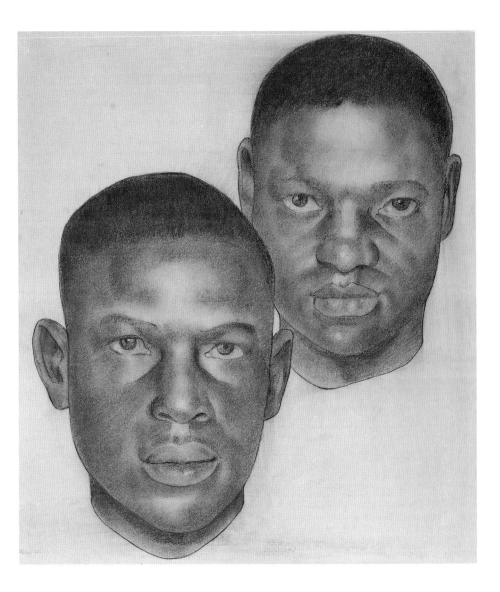

In politics, mention of the Great Depression evokes Franklin D. Roosevelt's New Deal; in painting, it summons up images of federally funded Work Projects Administration murals depicting the nation's workforce. And in American letters, the work most synonymous with those hard times is *The Grapes of Wrath*, John Steinbeck's best-selling novel portraying the spirit-breaking poverty that overtook so much of the country's rural economy in the wake of prolonged drought and falling crop prices. When the book appeared in 1939, Steinbeck had already tasted popular success with his two novels *Tortilla Flat* (1935) and *Of Mice and Men* (1937). *The Grapes of Wrath*, however, earned him an acclaim that few American writers have enjoyed. No recent novel, one critic said at its publication, was "better calculated to awaken the humanity of others." In 1962, Steinbeck's literary accomplishments earned him the Nobel Prize for Literature. FSV

John Steinbeck
(1902–1968)

Sonya Noskowiak (1900–1975)
Gelatin silver print, 8⁹/₁₆ x 7¹/₄ ins
(21.7 x 18.4 cm), 1935
© Estate of Sonya Noskowiak
NPG.81.14

In the early decades of the twentieth century, when waves of immigration and explosive urban growth transformed the face of America, George Gershwin emerged as a transcendent voice of modernism. His staccato-paced, syncopated rhythms helped define the Jazz Age on Broadway in the 1920s in such shows as *Lady Be Good* and *Girl Crazy*. At the height of the Great Depression, his "folk opera" *Porgy and Bess* attempted to catch the clashes and blends of cultural "interfusions" that he saw as distinctively American. And he was part of the Hollywood scene during the golden age of the silver screen, notably completing—with his lyricist brother Ira—the score for *The Goldwyn Follies* just before his death in 1937, at thirty-nine. Gershwin had become a centrifugal force in the performing arts in a period marked by a search for a modern American identity. AEH

George Gershwin
(1898–1937)

Arthur Kaufman (1888–1971)
Oil on canvas, 36^1/$_4$ x 24^1/$_2$ ins
(92.1 x 62.2 cm), 1936
NPG.73.8

By 1937, when Clark Gable and Jean Harlow posed for this promotional picture for their film *Saratoga*, both were at their box office peaks. Harlow established herself as Hollywood's leading sex goddess with her performance in *Hell's Angels* in 1931, but she really came into her own in 1933 with *Bombshell*, in which her brilliant parody of her own siren reputation revealed a substantial gift for comedy. One of MGM's top stars, Gable had already won a Best Actor Oscar for *It Happened One Night* (1934), and he would soon be tapped for his most celebrated role, the rakish Rhett Butler in the 1939 screen epic *Gone with the Wind*. Gable and Harlow shared top billing in a number of pictures. Unfortunately, *Saratoga* was to be their last co-starring venture. Two months before the picture's release, Harlow died from uremic poisoning. FSV

Clark Gable
(1901–1960) and
Jean Harlow
(1911–1937)

Clarence Sinclair Bull (1895–1979)
Gelatin silver print, 14 x 11 ins
(35.6 x 27.9 cm), 1937
NPG.81.13
© Estate of Clarence Sinclair Bull

Considered the mother of modern dance in America, not least for her seminal *Appalachian Spring* (1944), Martha Graham brought dance into the vortex of the machine age: the idea of motion was a fundamental tenet of modernism, and Graham was determined to extract dance from its balletic— and European—classicism and infuse it with "significant movement, ... with excitement and surge." She studied at Ruth St. Denis and Ted Shawn's Denishawn School from 1916 to 1923 and then worked at the Greenwich Village Follies, where she began to design and choreograph her own dances. By 1935 she had established the Martha Graham School for Contemporary Dance, and its first performance, "Frontier," reflected her notion that "life today is nervous, sharp, and zigzag." Graham continued to perform until she was seventy-six and created new ballets until her death. AEH

Martha Graham
(1894–1991)

Paul R. Meltsner (1905–1966)
Oil on canvas, 42 x 32 ins
(106.7 x 81.3 cm), 1938
NPG.73.41

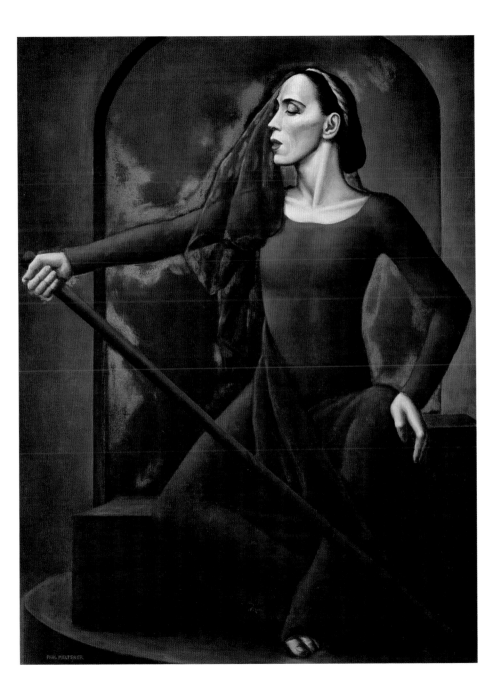

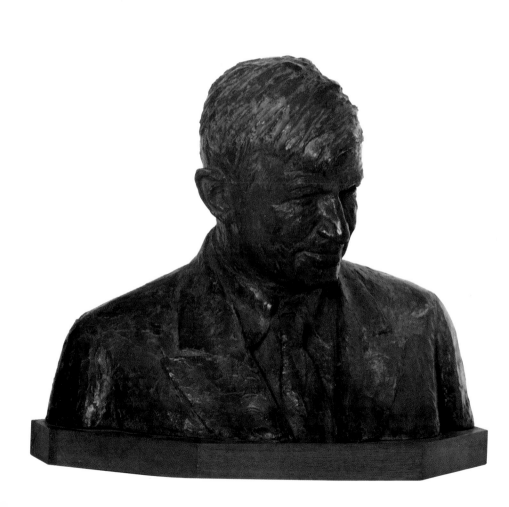

Will Rogers, who was part Cherokee, once told a Boston audience, "My ancestors didn't come over on the *Mayflower*—they met the boat." He spent his youth in traveling circuses as a rope artist and roughrider, later adding jokes to his lariat tricks. Eventually he wound up on the vaudeville circuit, and by 1912 was on Broadway, where he became a star of the Ziegfeld *Follies*. He also embarked on a motion picture and then a radio career that would establish him as America's homespun philosopher. When he died in an airplane crash in 1935, Rogers was arguably the nation's best-loved personality. AEH

Will Rogers
(1879–1935)

Jo Davidson (1883–1952)
Bronze, height 18³/₄ ins (47.6 cm)
(with base), cast after 1938 original
NPG.67.52

Born into slavery, George Washington Carver overcame the obstacles of slender means and racial discrimination to seek an education. He believed that "when you can do the common things of life in an uncommon way, you will command the attention of the world." These words, coupled with his lifelong goal to help poor black farmers trapped in sharecropping and dependency on cotton as a crop, pervaded his work at Alabama's Tuskegee Institute, where he was director of agricultural teaching and research for nearly forty years. Carver's laboratory investigations led to the discovery of more than 450 new commercial products—ranging from margarine to library paste—that could be extracted from previously untapped sources such as the peanut and sweet potato. He demonstrated for southern farmers the wisdom of diversifying crops, instead of relying mainly on the soil-exhausting crop of cotton. CLW

George Washington Carver
(1864–1943)

Betsy Graves Reyneau (1888–1964)
Oil on canvas, 45$\frac{1}{4}$ x 35$\frac{1}{4}$ ins
(114.9 x 89.5 cm), 1942
Gift of the George Washington Carver
Memorial Committee
NPG.65.77

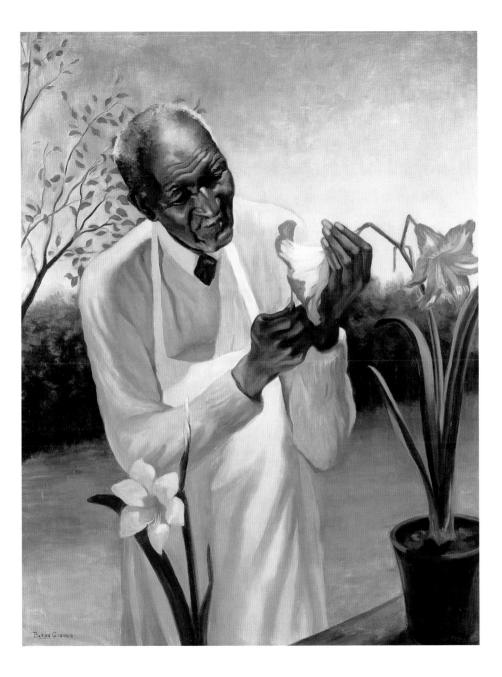

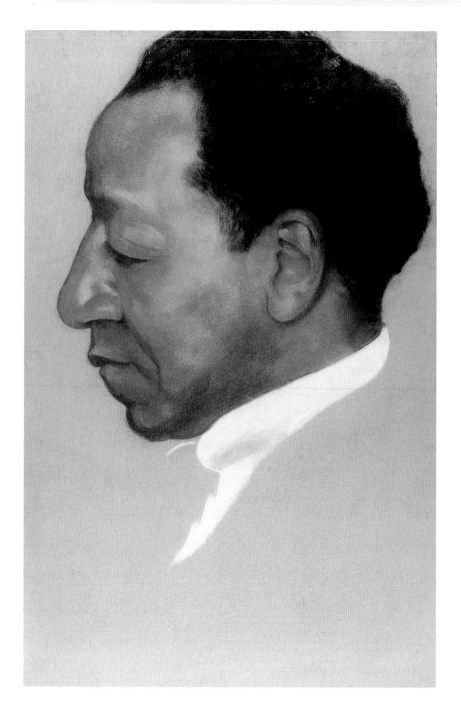

Georgia O'Keeffe's pastel portrait honors Beauford Delaney's perseverance and courage in the face of difficulty. As a gay black painter, Delaney faced many challenges, impeded as he was by sexual, cultural, and racial stereotyping and eventually beset by psychological problems. Born in Knoxville, Tennessee, Delaney studied in Boston and then settled in New York City before his final migration to Paris. In Greenwich Village and Harlem, Delaney befriended musicians and writers and was introduced to several artists, including Georgia O'Keeffe. Although portraiture is rare in her work, O'Keeffe greatly admired Delaney and found him attractive: "dark—clean—really beautiful." She rendered her subject in much the same manner as her still lifes of bones, rocks, or flowers. Isolating Delaney's profile against a neutral background, she used minute tonal gradations and beautifully blended pastels to create a powerful, timeless symbol of human endeavor. WWR

Beauford Delaney
(1901–1979)

Georgia O'Keeffe (1887–1986)
Pastel on paper, $19^1/_4$ x $12^3/_4$ ins
(48.9 x 32.4 cm), 1943
Gift of the Georgia O'Keeffe Foundation
NPG.2002.1
© 1938 The Georgia O'Keeffe Foundation

At the outbreak of World War II, the armed services practiced a rigid discrimination against African Americans that included a stubborn reluctance to acknowledge black capabilities, no matter how obvious. A prime example was the case of navy messman Dorie Miller. When Japan attacked Pearl Harbor on December 7, 1941, Miller was stationed there on the *West Virginia*. By the time he abandoned ship, he had braved enemy fire to carry his wounded commanding officer to safety and, though not trained for combat, had manned an antiaircraft gun, possibly downing at least one enemy plane. His bravery initially went unrecognized, however, and only after much pressure from the nation's black press did Miller finally receive the Navy Cross. But once acknowledged, Miller's heroism became a means, through posters such as this one, for rallying African Americans to the war effort. FSV

Dorie Miller
(1919–1943)

David Stone Martin (1913–1992)
Color halftone poster, 28$^1/_{16}$ x 20$^1/_4$ ins
(71.2 x 51.4 cm), 1943
NPG.88.173

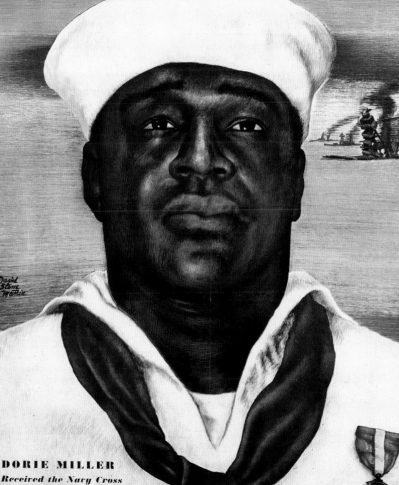

"above and beyond the call of duty"

DORIE MILLER

*Received the Navy Cross
at Pearl Harbor, May 27, 1942*

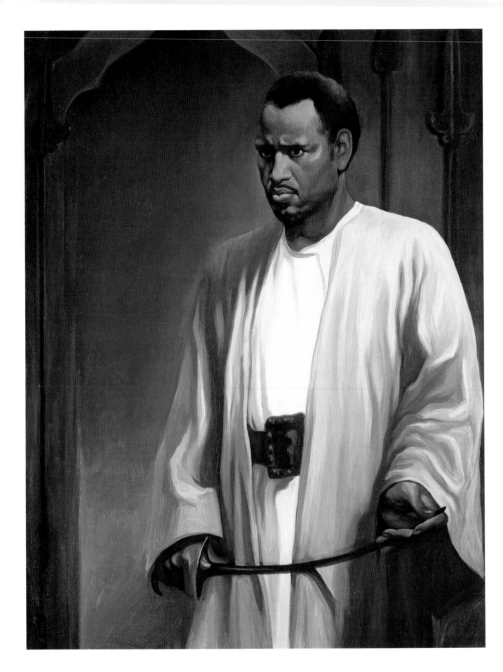

Paul Robeson's appearance in *The Emperor Jones* catapulted him to stardom in 1925, and his popularity soared with a 1943 *Othello* that ran for nearly three hundred performances in New York. He is perhaps best known, however, for his portrayal of Joe in both the stage and movie versions of *Show Boat*, singing "Ol' Man River." He stopped making films in 1942, explaining, "The industry is not prepared to permit me to portray the life or express the living interests, hopes, and aspirations of the struggling people from whom I come." Robeson's left-wing sentiments became a focal point of anti-Communism in the postwar era, and his American career largely came to an end. He lived abroad, returning to the United States for a farewell concert at Carnegie Hall in 1958; he lived his later years in seclusion in Philadelphia. AEH

Paul Robeson
(1898–1976)

Betsy Graves Reyneau (1888–1964)
Oil on canvas, 50$^{1}/_{4}$ x 38$^{1}/_{4}$ ins
(127.6 x 97.2 cm), 1944
Gift of the Harmon Foundation
NPG.67.86

Nicknamed "Old Blood and Guts," General George Patton had a penchant for harsh, bluntly spoken opinions that sometimes made him the object of controversy during World War II. There was, however, no debating his soldiering abilities. In the Allied drive against Axis armies in North Africa, his gift for instilling frontline discipline was critical in shaping unseasoned American soldiers into effective fighting units. His leadership proved crucial again in the invasion of Sicily, but his finest moment came during the massive German counteroffensive in northern Europe's Ardennes region in 1944–45. His part in repelling the Germans there placed beyond challenge his reputation as one of the most brilliant field commanders of the war.

The inscription in the portrait's upper left corner was from Patton's declaration of May 9, 1945, telling his soldiers what an honor it had been to lead them. FSV

George S. Patton
(1885–1945)

Boleslaw Jan Czedekowski (1885–1969)
Oil on canvas, 50 x 40⅝ ins
(127 x 103.2 cm), 1945
Gift of Major General George S. Patton,
U.S.A., Retired, and the Patton family
NPG.99.5

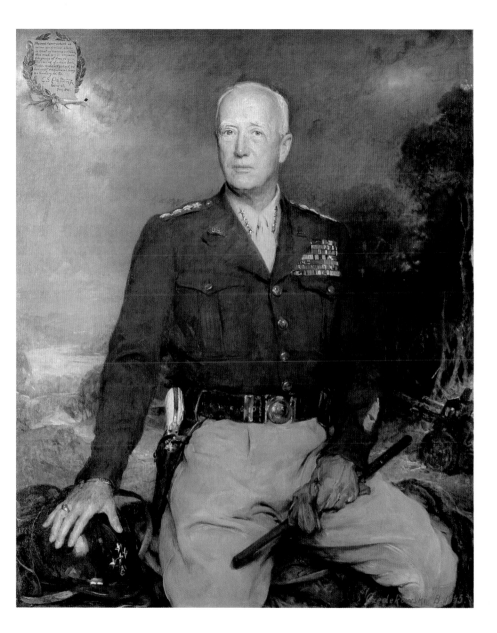

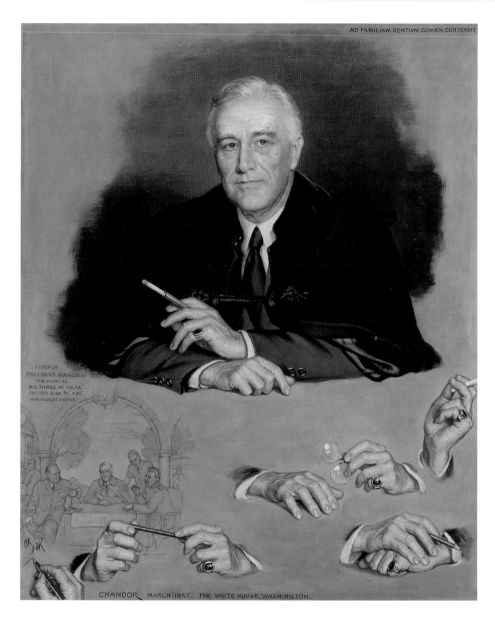

AD FAMILIAM GENTIVM COMEM CONTENDIT

STUDY OF
PRESIDENT ROOSEVELT
FOR PAINTING
"BIG THREE AT YALTA"
CANVAS SIZE 91" x 93"
WITH OUTLINE SKETCH

CHANDOR MARCH: 1945. THE WHITE HOUSE, WASHINGTON.

When Franklin Roosevelt began serving in New York's state legislature in 1911, some observers declared him ill-suited to the rough realities of politics. But Roosevelt thrived on those realities; some two decades later, he was advancing from the New York governorship to the presidency.

Taking office against the bleak backdrop of the Great Depression, Roosevelt responded quickly to this economic disaster with a host of regulatory and welfare measures—referred to as the New Deal—that redefined the government's role in American life. Among conservatives, the new federal involvement in matters traditionally left to the private sector was a betrayal of America's ideals. But in other quarters, Roosevelt's activism inspired an unwavering popularity that led to his election for an unprecedented four terms.

When Roosevelt sat for this portrait in 1945, his presidential concerns had long since shifted to guiding the nation through World War II. This likeness is a study for a larger painting—a sketch of which appears at the lower left—commemorating Roosevelt's meeting with the wartime Allied leaders Winston Churchill and Joseph Stalin at Yalta. FSV

Franklin D. Roosevelt
(1882–1945)

Douglas Chandor (1897–1953)
Oil on canvas, 43$\frac{1}{2}$ x 35$\frac{1}{2}$ ins
(110.5 x 90.2 cm), 1945
NPG.68.49

The singer and actress Lena Horne helped break the color barrier in mainstream popular culture in the mid-twentieth century, beginning her stage career in the chorus at Harlem's Cotton Club in 1933, where Duke Ellington (see p. 206) and Cab Calloway mentored her. In 1942, Hollywood beckoned, but her roles were often musical cameos that southern theaters could cut; Horne once said that *Stormy Weather* and *Cabin in the Sky* (both 1943) were the only films "in which I played a character who was involved in the plot." She became Hollywood's highest-paid African American actor, and her renditions of "Stormy Weather" and "Just One of Those Things" were considered classics. During this time, Horne became a vocal spokesperson for civil rights. She also continued to enjoy a successful nightclub and recording career, and triumphed in the 1980s with her one-woman show, *Lena Horne: The Lady and Her Music*. AEH

Lena Horne
(born 1917)

Edward Biberman (1904–1986)
Oil on canvas, 51 x 31 ins
(129.5 x 78.7 cm), 1947
NPG.85.2
© 1947 Edward Biberman

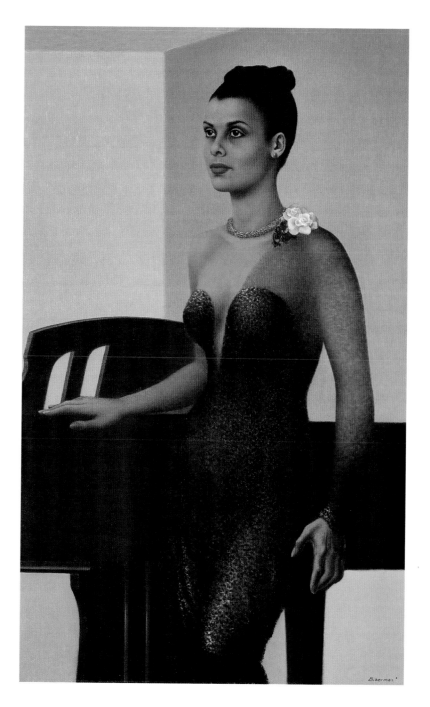

Biberman

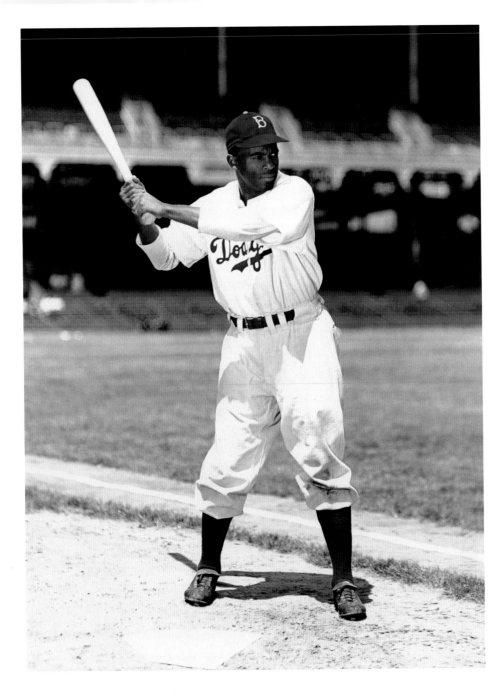

As the first African American to play major league baseball, Jackie Robinson was a pioneer in major league professional sports. This 1947 photograph by Harry Warnecke pictures Robinson at Ebbets Field during his first season with the Brooklyn Dodgers. That year was both glorious and unnerving. While winning Rookie of the Year honors and helping the Dodgers to win the National League pennant, Robinson faced intense scrutiny. As he later recalled, "I had to fight hard against loneliness, abuse, and the knowledge that any mistake I made would be magnified because I was the only black man out there." A lifetime .311 hitter, Robinson led the Dodgers to six pennants and one World Series title during his ten-year career. After baseball, he continued to champion the cause of civil rights, serving as the chairman of the NAACP Fight for Freedom Fund. FHG

Jackie Robinson
(1919–1972)

Harry Warnecke (1900–1984)
Color carbro print, 12³/₄ x 10¹/₈ ins
(32.4 x 25.7 cm), 1947
NPG.97.219
© *New York Daily News*, LP

George C. Marshall was, according to one expert observer, the "perfect" soldier. Endowed with a quick mind, a good memory, and a superb sense of strategy, he did not particularly relish war. Yet as chief of staff during World War II, he proved to be a masterful orchestrator of military mobilization. In 1945, President Harry Truman, who took office following the death of Roosevelt that year, remarked that millions of Americans had served the country well in that conflict, but it had been Marshall who "gave it victory." As capable in peace as in wartime, Marshall later became Truman's secretary of state, and it was he who unveiled in 1947 the American aid program for rebuilding Europe's war-ravaged economies. Ultimately named the Marshall Plan, this venture became one of the greatest triumphs in the entire history of American diplomacy. FSV

George C. Marshall
(1880–1959)

Thomas E. Stephens (1886–1966)
Oil on canvas, 50 x 39 15/16 ins
(127 x 101.5 cm), c. 1949
Gift of Ailsa Mellon Bruce
NPG.65.66

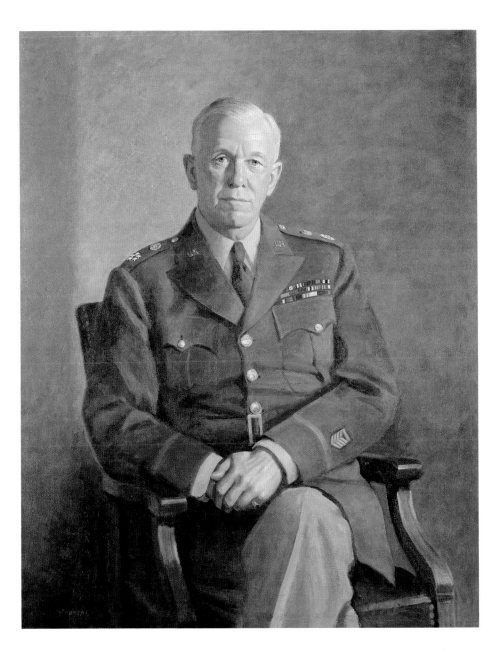

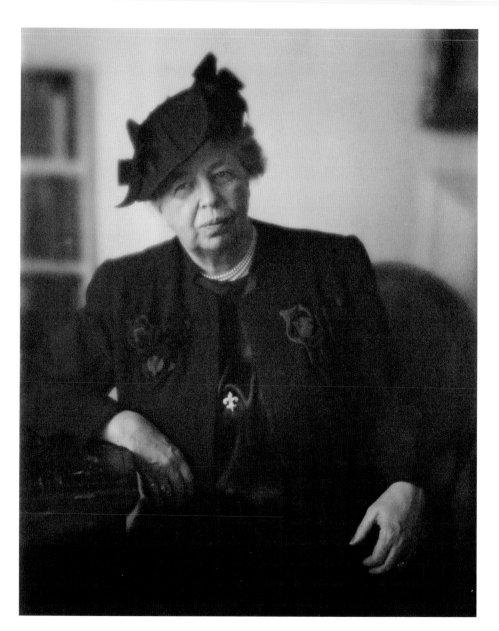

When Franklin D. Roosevelt took the presidential oath in March 1933, his wife, Eleanor, entered the White House declaring that she was "just going to be plain, ordinary Mrs. Roosevelt. And that's all." The reality proved to be quite different, however, for Eleanor Roosevelt soon emerged as a vital player in her husband's administration. She took the lead on a number of social issues, but, most important, she acted as her husband's conscience, urging him toward measures he might otherwise have avoided for the sake of expedience. The activism that marked Eleanor Roosevelt's tenure as first lady did not end with her departure from the White House. As a delegate to the United Nations, she was instrumental in formulating the Universal Declaration of Human Rights and securing its ratification in 1948, thereafter earning the affectionate title "First Lady of the World." FSV

Eleanor Roosevelt
(1884–1962)

Clara E. Sipprell (1885–1975)
Gelatin silver print, $9^{13}/_{16}$ x $7^{15}/_{16}$ ins
(25 x 20.2 cm), 1949
NPG.77.140

The comedienne Lucille Ball's television antics entertained audiences for more than two decades. From the beginning of her career, Ball constantly landed small parts in movies, yet she felt unchallenged and miscast in these roles. Opportunity for change arose in 1950 when CBS offered her the chance to star in a new show based on her radio series, *My Favorite Husband*. When she insisted that her husband, the Cuban musician Desi Arnaz, co-star in the series, CBS balked, finally relenting when the couple agreed to produce the pilot. *I Love Lucy* ran for six years and was one of the most popular shows of all time. "This is fun, not work," Ball said of the show that changed the Monday-night habits of Americans, closing department stores, taking taxis off the street, and gluing families to their television sets. MSS/ACG

Lucille Ball
(1911–1989)

Philippe Halsman (1906–1979)
Gelatin silver print, 13^{11}/$_{16}$ x 10^5/$_8$ ins
(34.7 x 27 cm), 1950
NPG.2004.39
© Halsman Estate

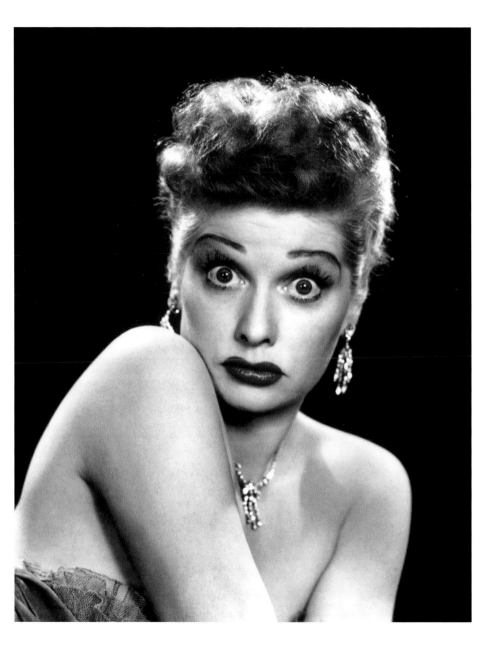

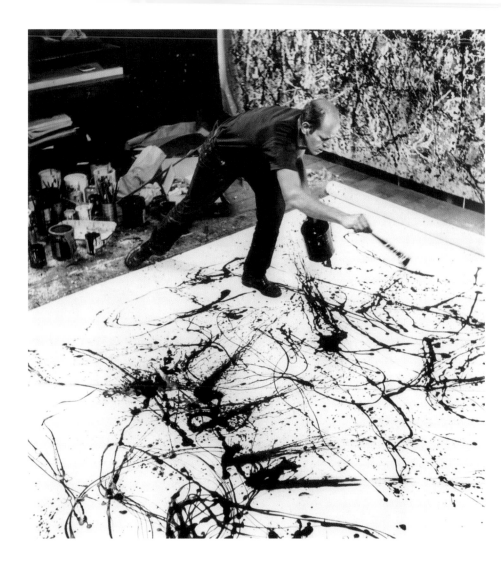

Jackson Pollock stood at the pinnacle of abstract expressionism in post–World War II America. "On the floor I am more at ease. I feel nearer, more a part of the painting, since this way I can walk around it, work from the four sides and literally be in the painting." In a series of 500 photographs and two films, the photographer Hans Namuth captured Pollock's "action painting," revealing his signature paint-pouring technique to the world. Most important, Namuth captured Pollock's eccentric artistic ritual, which included dancing around, and often on, an unstretched canvas on the studio floor while unconsciously painting with brush, spatula, or even directly from a paint can. Through the act of artistic creation, Pollock sought self-control and self-discovery, often realizing both, or, regrettably, sometimes neither. Ironically, both Pollock and Namuth died in auto accidents thirty-four years—but only a few miles—apart. JLB

Jackson Pollock
(1912–1956)

Hans Namuth (1915–1990)
Gelatin silver print, 14^{13}/$_{16}$ x 13^{13}/$_{16}$ ins (37.6 x 35.1 cm), 1950
Gift of the Estate of Hans Namuth
NPG.95.155
© Estate of Hans Namuth

Commander of American land forces in the Pacific at the outbreak of World War II, General Douglas MacArthur suffered the worst defeat of his career in the spring of 1942, when he was forced to flee the Philippines in the wake of the Japanese invasion. Uttering, on his arrival in Australia, his famous words, "I shall return," MacArthur now faced the task of repelling Japan's drive for dominion in the southwest Pacific. His success in that effort, combined with his own genius for self-promotion in the press, made him one of the most popular heroes of the war back in civilian America. By the time he made good his promise to retake the Philippines in spring 1945, his reputation had reached legendary proportions, and the following September he was chosen to preside over Japan's final surrender. FSV

Douglas MacArthur
(1880–1964)

Howard Chandler Christy (1873–1952)
Oil on canvas, 54¼ x 39½ ins
(137.8 x 100.3 cm), *c.* 1952
Gift of Henry Ostrow
NPG.78.271

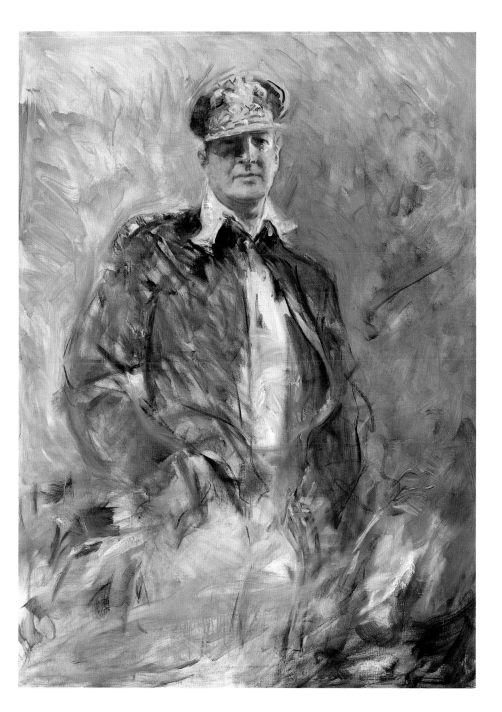

After brief appearances in Broadway plays and television shows, the actor James Dean starred in three major motion pictures, two of which were released following his death. He received posthumous Academy Award nominations for his performances in *East of Eden* (1955) and *Giant* (1956), and became forever identified with the defiant character he portrayed in *Rebel Without a Cause* (1955). Introduced to Dean through a mutual friend in 1954, Roy Schatt photographed him throughout the year and taught him rudimentary camera skills. During their outings, the two often took turns photographing one another. Schatt took this portrait, made with available light, during a visit to Dean's tiny New York apartment. He later called Dean "a paradoxical combination of egomaniac and loner, wanting to be seen yet hiding from the public." MSS

James Dean

(1931–1955)

Roy Schatt (1909–2002)
Gelatin silver print, 13^{11}/$_{16}$ x 16^{5}/$_{8}$ ins (34.7 x 42.2 cm), 1954
Gift of Mr. and Mrs. Roy Schatt
NPG.91.209
© Roy Schatt

During the Cold War, the artist Ben Shahn and the physicist J. Robert Oppenheimer both became targets of the House Un-American Activities Committee's anti-Communist suspicions. In Oppenheimer, the "father" of the atomic bomb, the intensely politicized Shahn found a perfect subject. Although widely acclaimed as a scientist, Oppenheimer was declared a security risk for his misgivings about the bomb.

Shahn made a number of drawings of Oppenheimer, all reflecting a sense of unease. Here, the rigid, vertical torso recalls gaunt medieval figures of saints and martyrs. The ragged, barbed quality of the line, a sharp-edged, almost painful presence on the page, transforms the portrait into a symbol of troubled humanity. Shahn's art "has never lost its fighting edge," one critic wrote, "its profound concern with justice and truth." WWR

J. Robert Oppenheimer
(1904–1967)

Ben Shahn (1898–1969)
Ink on paper, 11^{11}/$_{16}$ x 5^{1}/$_{4}$ ins
(29.7 x 13.3 cm), 1954
NPG.84.192
© Estate of Ben Shahn/Licensed by VAGA, New York, NY

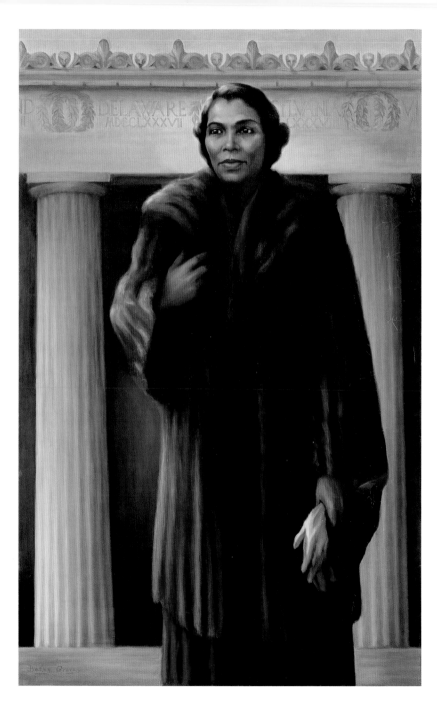

One of the outstanding voices of the twentieth century, the contralto Marian Anderson—like many African American artists of the time—first achieved success in Europe. The impresario Sol Hurok convinced her to return to America, and a triumphant 1935 concert secured her reputation. In 1939, she became embroiled in a historic event when the Daughters of the American Revolution banned her appearance at their association's Constitution Hall because she was black. First Lady Eleanor Roosevelt (see p. 188) intervened and facilitated Anderson's Easter Sunday outdoor concert at the Lincoln Memorial—an event attended by 75,000 people and broadcast to a radio audience of millions. In 1955, Anderson was invited to appear at the Metropolitan Opera (in Verdi's *Un Ballo in Maschera*), becoming the first African American to sing an important role with that company. In 1978, she received a Kennedy Center Honors award. AEH

Marian Anderson
(1897–1993)

Betsy Graves Reyneau (1888–1964)
Oil on canvas, 60$\frac{1}{4}$ x 38$\frac{3}{8}$ ins
(153 x 97.5 cm), 1955
Gift of the Harmon Foundation
NPG.67.76

Audrey Hepburn's first major motion picture, *Roman Holiday* (1953), won the actress an Academy Award and launched a career that would make her one of the most celebrated movie stars of her generation. Successful films such as *Sabrina* (1954), *Breakfast at Tiffany's* (1961), and *My Fair Lady* (1964), along with a lifelong friendship and collaboration with the couturier Hubert de Givenchy, helped to maintain Hepburn's image of elegance and poise. In this portrait, the newly married actress posed for the celebrity photographer Philippe Halsman in her rented villa outside Rome during the shooting of *War and Peace*. A variant of this image appeared on the cover of *Life* magazine in 1955. Halsman captures Hepburn's delicate beauty and impish charm, which won the hearts of audiences everywhere. Late in her life, Hepburn became a goodwill ambassador for UNICEF, committing herself to raising awareness of impoverished children around the globe. MSS

Audrey Hepburn
(1929–1993)

Philippe Halsman (1906–1979)
Gelatin silver print, $13^{3}/_{4} \times 10^{5}/_{8}$ ins
(34.9 x 27 cm), 1955
NPG.95.96
© Halsman Estate

In a postwar opera world that needed stars, Maria Callas was said to have "restored the ancient luster to the title of prima donna." Born in New York and raised in Greece, Callas, by sheer force of personality coupled with supreme artistry, rejuvenated the public's interest in this classic music genre. She brought renewed attention to the bel canto works of Bellini and Donizetti, and influenced the next generation of singers such as Beverly Sills, Joan Sutherland, and Marilyn Horne. Part of Callas's cachet was her volcanic temperament—"I will always be as difficult as necessary to achieve the best"—which ultimately found her fired from the Metropolitan Opera and ostracized by the Chicago Lyric, among other companies. Her box office quotient was so high, however, that most of them eventually welcomed her back. AEH

Maria Callas
(1923–1977)

Henry Koerner (1915–1991)
Oil on canvas, 22 x 28 ins
(55.9 x 71.1 cm), 1956
Time cover, October 29, 1956
Gift of *Time* magazine
NPG.78.TC271

In the first rank of American composers, Duke Ellington was—to use a favorite phrase of his own—"beyond category." He produced what has been called the "single most impressive body of composition in American jazz": more than two thousand pieces that ranged from such popular classics as "Satin Doll" and "Sophisticated Lady" to extended works such as *Black, Brown and Beige*, which premiered at Carnegie Hall in 1943. Ellington continually expanded his work as a composer and bandleader, writing music for Broadway (*Beggar's Opera*) and Hollywood (including the film score for *Anatomy of a Murder*), undertaking extensive international tours, and working with younger jazz musicians such as John Coltrane, Charles Mingus, and Max Roach. He received the 1965 Pulitzer Prize for his long-term achievement and the Presidential Medal of Freedom in 1969. AEH

Duke Ellington
(1899–1974)

Peter Hurd (1904–1984)
Tempera on board, 19 x 13½ ins
(48.3 x 34.3 cm), 1956
Time cover, August 20, 1956
Gift of *Time* magazine
NPG.78.TC353

PETER HURD

Thurgood Marshall played a major role in the 1940s and 1950s as a leader in the struggle to end racial discrimination in the United States. From 1938 to 1961, he served as chief staff lawyer for the National Association for the Advancement of Colored People (NAACP). Marshall devoted much effort to tailoring arguments that led the Supreme Court to its unanimous 1954 *Brown v. the Board of Education of the City of Topeka* decision, which ruled segregation of public schools by race to be unconstitutional. But he realized the struggle was not over. At a party celebrating the *Brown* decision, Marshall warned his colleagues, "I don't want any of you to fool yourselves, it's just begun, the fight has just begun." He went on to become the first African American justice of the Supreme Court, nominated by President Lyndon Johnson in 1967. CLW

Thurgood Marshall
(1908–1993)

Betsy Graves Reyneau (1888–1964)
Oil on canvas, 50 x 32 ins (127 x 81.3 cm), 1956
Gift of the Harmon Foundation
NPG.67.43

"The only people for me are the mad ones, the ones who are mad to live, mad to talk, mad to be saved ... the ones who ... burn, burn, burn like fabulous yellow roman candles." Like his character Sal Paradise in *On the Road*, Jack Kerouac was restless to discover himself in postwar America. His stream-of-consciousness writing style flowed like jazz, encompassing but not always embracing the Beat generation of the 1950s. Hitchhiking with his friend Neil Cassady gave birth to *On the Road* (1957), which became an instant success. The manuscript, like the roads he traveled, embodied Kerouac's marathon urge to create, having been typed on a continuous roll of taped-together paper measuring 120 feet in length. Troubled by fame, critics, and his inability to break free of beatnik stereotypes, Kerouac sought solace in alcohol, which led to his early death. JLB

Jack Kerouac
(1922–1969)

Fred W. McDarrah (born 1926)
Gelatin silver print, 7 1/16 x 6 1/16 ins
(18 x 15.4 cm), 1959
NPG.2002.97
© Fred W. McDarrah

Henri Cartier-Bresson's photograph shows Malcolm X sitting at a restaurant table before a framed poster of Elijah Muhammad. It was Muhammad, head of the black separatist group Nation of Islam, who was most responsible for redirecting the former Malcolm Little from the life of a petty criminal to that of a national civil rights leader.

Malcolm X rose to his position of authority in the early 1960s as an outspoken critic of Martin Luther King Jr. (see p. 220) and others who were, in his words, "begging for integration." The Nation of Islam has "shaken up the white man by asking for separation," he said in 1961. Although Malcolm X would later reject the Nation of Islam and make peace with King, he was instrumental in making the civil rights campaign more militant and in planting the seeds of the Black Power movement. FHG

Malcolm X
(1925–1965)

Henri Cartier-Bresson (1908–2004)
Gelatin silver print, $9^{13}/_{16}$ x $6^{5}/_{8}$ ins
(25 x 16.8 cm), 1961
NPG.2004.33
© Henri Cartier-Bresson/Magnum Photos

Frustrated by racism in the United States, the writer James Baldwin traveled to Paris in 1948, where he began to gain recognition for his critical essays, particularly *Notes of a Native Son* (1955). Baldwin was most successful when writing about personal events, as he did in his powerful narrative of a life-changing religious experience, *Go Tell It on the Mountain* (1953). Religion greatly influenced Baldwin, but he later broke with the Church after a homosexual relationship drove him to question his beliefs. Baldwin was often criticized by the black community for his participation in gay-rights activism, despite the prominent role he played in the early civil rights movement.

Beauford Delaney had once served as a surrogate "father in art" to the teenaged Baldwin, who was inspired by his ideas. Glowing with the Van Gogh–inspired yellow that Delaney favored after his move to Paris in the 1950s is this pastel, both a likeness based on memory and a study of light. JGB/WWR

James Baldwin
(1924–1987)

Beauford Delaney (1901–1979)
Pastel on paper, $25^{1}/_{2}$ x $19^{5}/_{8}$ ins
(64.8 x 49.8 cm), 1963
NPG.98.25

Medgar Evers (on right, with sign) played a critical role in organizing and sustaining the Jackson Movement—a multifaceted campaign to end segregation in Mississippi's most populous city. In the spring of 1963, Evers launched a boycott of stores in Jackson's main shopping district after the city's mayor rejected a resolution sponsored by the NAACP (National Association for the Advancement of Colored People) calling for fair hiring practices in municipal jobs, desegregation of public facilities and accommodations, an end to discriminatory business practices, and the establishment of a biracial committee to combat injustice and promote reform. When the NAACP's national secretary Roy Wilkins joined Evers in picketing the F.W. Woolworth store in downtown Jackson, both men were swiftly arrested by local police brandishing electric cattle prods. This press photograph documenting the arrest appeared in the *New York Times* on June 2, 1963—just ten days before Evers's assassination by a white supremacist, Byron de la Beckwith. AMS

Roy Wilkins
(1901–1981) and
Medgar Evers
(1925–1963)

Unidentified photographer
Gelatin silver print, $7^{5}/_{8} \times 9^{1}/_{2}$ ins
(19.4 x 24.2 cm), 1963
NPG.2001.81

When an assassin's bullet cut short John F. Kennedy's presidency in November 1963, the country experienced a collective sense of loss that it had not known since the death of Abraham Lincoln. But the grief was not so much inspired by Kennedy's presidential accomplishments as it was an expression of what he had come to represent: his eloquence and idealism had made him, in the eyes of many, the embodiment of this country's finest aspirations. Still, his administration could claim triumphs in foreign policy, including a successful face-off with the Soviets over the presence of missiles in Cuba. Its support for the civil rights movement, moreover, would soon give birth to landmark legislation promoting racial equality.

Elaine de Kooning arranged for sittings with Kennedy in late 1962, intending to complete a single portrait. Fascinated with the changeability of Kennedy's features, she instead painted an entire series of likenesses, including this one. In its loose, almost chaotic brushwork, the portrait illustrates de Kooning's close identification with the abstract expressionist movement of the 1950s. FSV

John F. Kennedy
(1917–1963)

Elaine de Kooning (1918–1989)
Oil on canvas, 103$\frac{1}{2}$ x 45$\frac{1}{2}$ ins
(262.9 x 115.6 cm), 1963
NPG.99.75
© Elaine de Kooning Trust

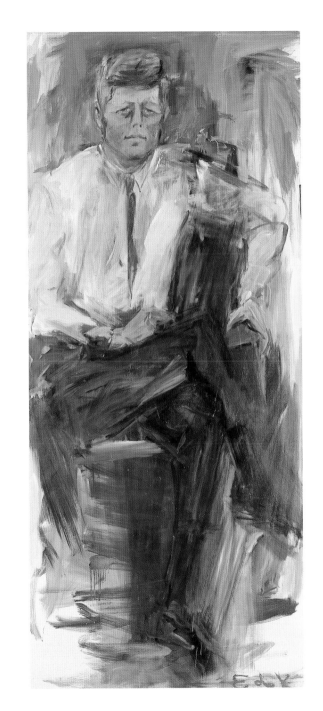

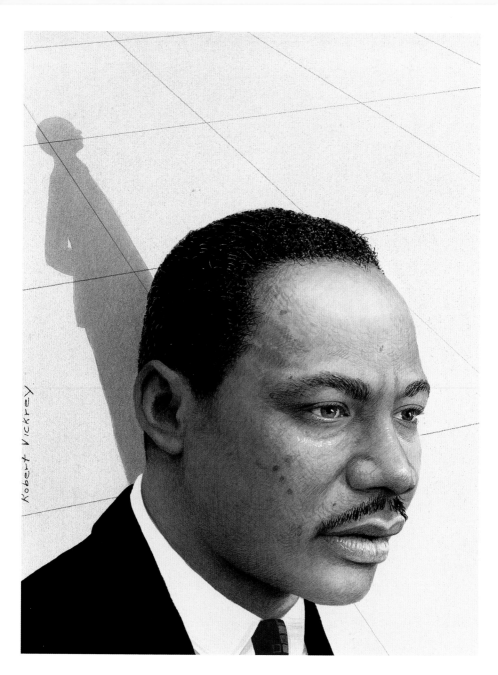

In the story of the civil rights movement of the 1950s and 1960s, the figure who came to personify the substantial gains made toward eliminating racial discrimination was a preacher from Atlanta, Martin Luther King Jr. A key strategist in such events as the Montgomery bus boycott and the nonviolent protests in Birmingham and Washington, D.C., he is remembered for his impassioned eloquence—"I have a dream that one day ... this great nation will rise up and live out the true meaning of its creed: 'We hold these truths to be self-evident, that all men are created equal.'"

Time magazine selected King as its 1963 Man of the Year, commissioning the artist Robert Vickrey to paint the cover image. By the end of that year, Congress would pass legislation mandating racial equality, which until then had seemed but a remote ideal. CLW

Martin Luther King Jr.
(1929–1968)

Robert Vickrey (born 1926)
Tempera on paper, 14³/₄ x 11¹/₄ ins
(37.5 x 28.5 cm), 1963
Time cover, January 3, 1964
Gift of *Time* magazine
NPG.78.TC517
© Robert Vickrey/Licensed by VAGA,
New York, NY

The soprano Leontyne Price trained at the Juilliard School and first scored a major success in 1952, appearing as Bess in a touring production of George Gershwin's *Porgy and Bess*. In 1955, she appeared in an NBC telecast of *Tosca* and was subsequently in high demand by opera houses in London, Vienna, and Milan. It was not until 1961 that she made her debut at the Metropolitan Opera—as Leonora in *Il Trovatore*—and she quickly became a Met favorite, remaining so until her farewell performance there in 1985. Especially associated with the work of Giuseppe Verdi and Samuel Barber, Price sang the female title role in *Antony and Cleopatra*—an opera that Barber created for her—at the opening of the Met's new home at Lincoln Center. Price was also a tireless performer on the recital circuit and won fifteen Grammys for her recordings. She received a Kennedy Center Honors award in 1980. AEH

Leontyne Price
(born 1927)

Bradley Phillips (1929–1991)
Oil on canvas, 50¹/₄ x 36¹/₄ ins
(127.6 x 92.1 cm), 1963
Gift of Ms. Sayre Sheldon
NPG.91.96

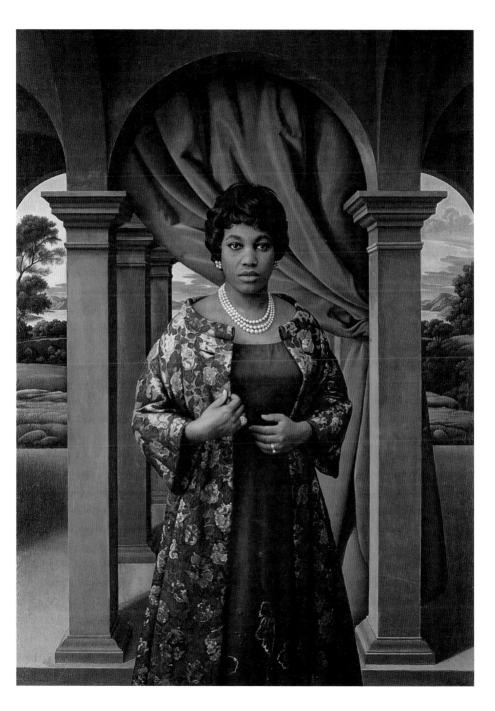

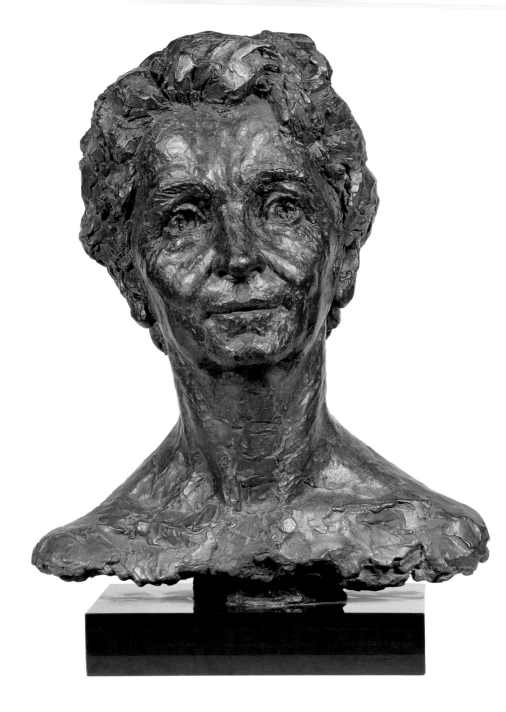

As a visiting nurse among the immigrants of New York City's Lower East Side in the early 1900s, Margaret Sanger was profoundly affected by the physical and mental toll exacted on women by frequent childbirth, miscarriage, and self-induced abortion. Sanger declared that "no woman can call herself free who does not own and control her body. No woman can call herself free until she can choose consciously whether she will or will not be a mother." She spent the rest of her life promoting the availability and use of birth control and is recognized nationally and internationally as a leader in the field. CLW

Margaret Sanger
(1879–1966)

Joy Buba (c. 1904–1998)
Bronze, height 20½ ins (52.1 cm)
(with base), 1972 cast after 1964 original
Gift of Mrs. Cordelia Scaife May
NPG.72.70

As a government scientist, Rachel Carson had become concerned about the ecological impact of pesticides, especially DDT, and in 1962 she published the groundbreaking *Silent Spring*. Finely written and passionately reasoned, *Silent Spring* exploded into the national consciousness and can be said to have started the modern environmental movement. It was not only an argument for ecological reform, but also a warning that an active citizenry had to be skeptical of the actions of large institutions, both private and public. This attitude of skepticism became a dominant theme in the political culture of the 1960s and 1970s. DCW

Rachel Carson
(1907–1964)

Una Hanbury (1904–1990)
Bronze, height 19⅛ ins (48.6 cm)
(with base), 1965
NPG.66.19

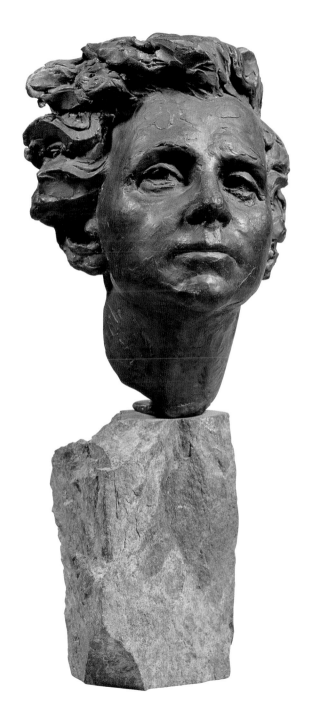

Poet, critic, magazine editor, and novelist, Lincoln Kirstein above all played a central role in shaping America's classical ballet tradition. Obsessed with dance from an early age, Kirstein brought the Russian choreographer George Balanchine of Diaghilev's Ballets Russes to the United States in the early 1930s, and together they founded the School of American Ballet. Their collaboration continued, and in 1948 they established the New York City Ballet, with Kirstein serving as general director until 1989. He also founded the Dance Archives of the Museum of Modern Art, which became the basis of the Dance Collection of the New York Public Library. The portraitist, Jamie Wyeth, was only nineteen when this painting was completed. AEH

Lincoln Kirstein
(1907–1996)

Jamie Wyeth (born 1946)
Oil on canvas, 39 x 30⅝ ins
(99.1 x 77.8 cm), 1965
Bequest of Lincoln Kirstein
NPG.96.97
© Jamie Wyeth

Casey Stengel built his reputation as one of baseball's greatest managers by guiding the New York Yankees to ten American League pennants and seven World Series championships in just twelve seasons (1949–60). But it was during his stint as the charismatic shepherd of the fledgling New York Mets (1962–65) that Stengel earned a place in the hearts of baseball lovers everywhere. Unable to budge his hapless team from the National League's cellar, Stengel nonetheless helped the Mets amass legions of loyal fans, thanks to his memorable quips, his tireless zest for the game, and his confident prediction that "the Mets are gonna be amazing." AMS

Casey Stengel
(1890–1975)

Rhoda Sherbell (born 1933)
Polychromed bronze, height 44 ins
(111.8 cm) (with base), 1981 cast after 1965
original
NPG.81.67
© Rhoda Sherbell

When you think of Bob Hope you instantly envision the jaunty irreverence of this consummate entertainer. Born in England and raised in Cleveland, Hope joined the vaudeville circuit as a teen. By the mid-1930s he was a fixture on radio and a star of such Broadway shows as Cole Porter's *Red, Hot & Blue*. He moved to Hollywood and by 1940 began the hugely popular series of "Road" movies, partnered with his golf buddy Bing Crosby. Hope's commitment to entertaining U.S. troops, from 1941 through the Gulf War, was legendary. He received five special Academy Awards and, in 1985, a Kennedy Center Honors award. AEH

Bob Hope
(1903–2003)

Marisol Escobar (born 1930)
Polychromed wood, height 18½ ins
(47 cm) (without base), 1967
Time cover, December 22, 1967
Gift of *Time* magazine
NPG.78.TC452
© Marisol/Licensed by VAGA,
New York, NY

Based on a publicity still from Marilyn Monroe's 1953 film *Niagara*, Andy Warhol's portrait of the film star conveys both her glamour and her fragility. A gifted performer, Monroe became an iconic sex symbol, entertaining troops in Korea and electrifying movie audiences. Despite her success, she maintained an air of vulnerability. Warhol capitalized on these contradictions, first portraying Monroe after her 1962 death from a drug overdose. Using silkscreens, he created multiple renditions of the actress. By emphasizing the images' off-register printing, Warhol created a powerful metaphor for the dissolution of Monroe's career and the blinding impact of her overexposure. In this screenprint, part of a series of ten, Monroe's sensual features dissolve into a nearly impenetrable mask as Warhol's non-naturalistic colors and their improper alignment produce a jarring effect at once familiar and alienating. ACG

Marilyn Monroe
(1926–1962)

Andy Warhol (1928–1987)
Screenprint, 36 x 36 ins (91.5 x 91.5 cm), 1967
Gift of Daniel Solomon
NPG.97.51
© Andy Warhol Foundation for the
Visual Arts/Artists Rights Society (ARS),
New York

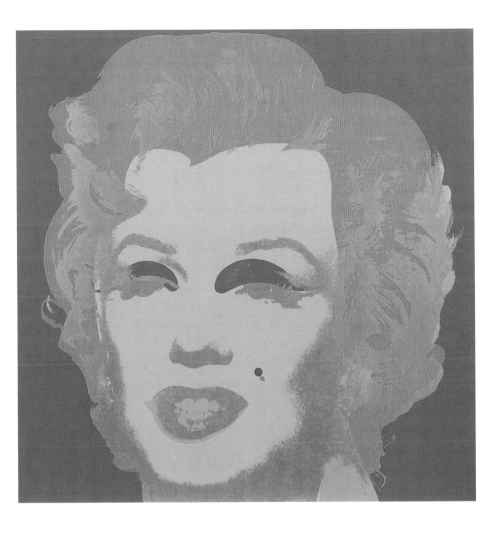

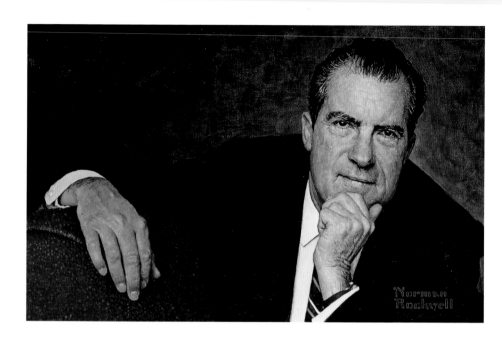

Richard Nixon owed his election as Dwight Eisenhower's vice president to his early reputation as an anti-Communist. By the time he became president in 1968, however, his thinking had shifted considerably. As a result, under his leadership the confrontational strategies that had long dominated this country's response to Communism gave way to a historic détente, marked by American recognition of Communist China and better relations with the Soviet Union.

These achievements, however, were eventually overshadowed by disclosure of the Watergate scandals—a web of illegal activity involving scores of Nixon's advisers. Although never implicated in the original crimes, Nixon did become party to attempts to cover them up. Following irrefutable disclosure of that fact, he became the only president ever to resign from office.

Norman Rockwell admitted that he had intentionally flattered Nixon in this portrait. Nixon's appearance was troublesomely elusive, Rockwell noted, and if he was going to err in his portrayal, he wanted it to be in a direction that would please the subject. FSV

Richard M. Nixon
(1913–1994)

Norman Rockwell (1894–1978)
Oil on canvas, 20⅝ x 28½ ins
(52.4 x 72.4 cm), 1968
Donated to the people of the United States of America by the Richard Nixon Foundation
NPG.72.2

Encouraged by the victories of the black civil rights movement, the labor organizer César Chávez began in the early 1960s to protest the unfair treatment of farm workers in California and the Southwest, the majority of whom were Mexican or Mexican American. In 1963, he and Dolores Huerta founded the United Farm Workers of America (UFW), the first effective national organization to represent agricultural workers and press for political reform. The UFW started a boycott of California grapes in 1965 as part of a movement to improve working conditions for field laborers. Four years later, *Time* magazine published this portrait as its cover image. The effects of the farm workers' strike, known as *la causa* (the cause), had spread, resulting in a national boycott of grapes by many sympathetic Americans. An Aztec eagle, the symbol of the UFW, is emblazoned on Chávez's shirt. CLW

César Chávez
(1927–1993)

Manuel Acosta (1921–1989)
Oil on canvas, 24 x 20 ins (61 x 50.8 cm), 1969
Time cover, July 4, 1969
Gift of *Time* magazine
NPG.78.TC298
© Estate of Manuel Acosta/
Adair Margo Gallery

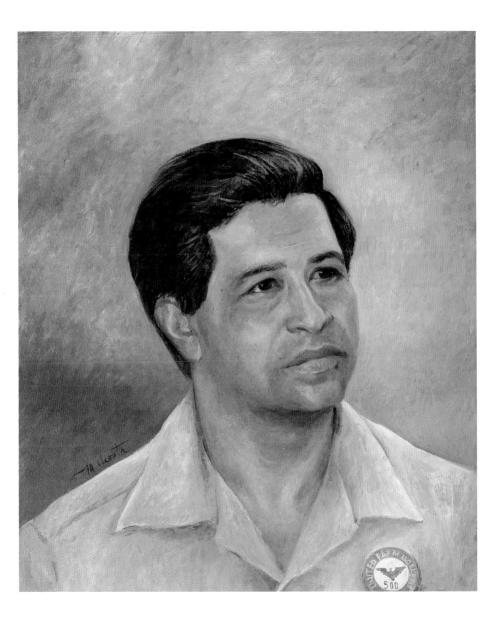

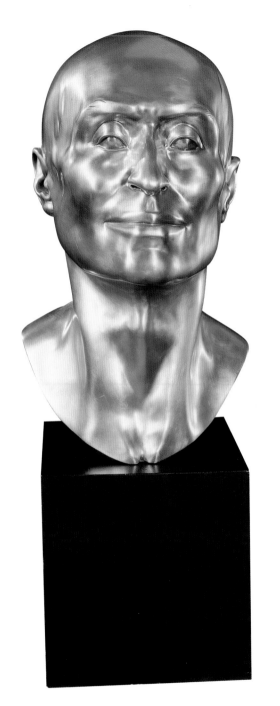

The concert dancer and choreographer José Limón came to the United States from Mexico in 1915 and began his long career on Broadway in 1928, notably as a leading dancer in the Doris Humphrey–Charles Weidman Company. Like Humphrey and Martha Graham (see p. 166), Limón advocated developing an indigenous American dance, a vision he later pursued with his own company, which he formed in 1946. His first major work, *The Moor's Pavane*, was hailed as "a magnificent piece of dance theater" and won the 1950 *Dance Magazine* award for achievement in choreography. His later works experimented with abstract themes and sound. AEH

José Limón
(1908–1972)

Philip Grausman (born 1935)
Bronze, height 19³/₄ ins (50.2 cm)
(with base), 1969
Gift of an anonymous donor
NPG.75.31
© Philip Grausman

The only person ever to have received two unshared Nobel Prizes, Linus Pauling both advanced science and addressed its social implications. In the 1930s and 1940s, Pauling applied quantum mechanics to chemistry, inspiring new discoveries about molecular structures and leading to his 1954 Nobel Prize for Chemistry. Pauling's resistance to atomic weapons fueled his publication of *No More War!* in 1958 and earned him a second Nobel Prize, this time for Peace, in 1962. A year later the Nuclear Test-Ban Treaty was implemented.

Alice Neel's informal portrait depicts the scientist outside of the laboratory, so indicating the breadth of his commitments. Pauling later explained, "I could have accomplished a lot more science from 1945 to 1965. I decided ... I ought to get scientists working for world peace. ... Scientists have an obligation to help fellow citizens make the right decisions." ACG

Linus Pauling
(1901–1994)

Alice Neel (1900–1984)
Oil on canvas, 49^3/$_4$ × 35^1/$_2$ ins
(126.4 × 90.2 cm), 1969
NPG.85.73
© Estate of Alice Neel

One of the archetypal heroic figures of twentieth-century film, John Wayne conveyed a decisive, solitary, reverent screen persona that reflected traditional American values. Wayne's collaboration with the director John Ford led to such classics as *Stagecoach* (1939), *She Wore a Yellow Ribbon* (1949), and *The Quiet Man* (1952). During World War II, Wayne starred in several morale-boosting movies, including *Flying Tigers* (1942) and *Back to Bataan* (1945). He finally won an Oscar for his portrayal of Rooster Cogburn in *True Grit* (1969). About his long-lived popularity he said, "I play John Wayne in every part regardless of the character, and I've been doing okay, haven't I?" AEH

John Wayne
(1907–1979)

Harry Jackson (born 1924)
Polychromed bronze, height 28 3/4 ins
(73 cm) (with base), 1969
Time cover, August 8, 1969
Gift of *Time* magazine
NPG.89.TC17

The emergence of the modern feminist movement in the 1960s had initially seemed but a sideshow beside the massive demonstrations for civil rights and against the Vietnam War. Yet it was clear that the growing cry for equal opportunity for women could not be ignored. In no small measure, the movement owed its quickening pulse to Kate Millett, whose book *Sexual Politics* (1970) had become something of a bible for feminism. When *Time* magazine sought a personification of feminist protest for its cover in August 1970, it, not surprisingly, settled on Millett. Unfortunately, Millett herself was not pleased with the choice, feeling that no one person could presume to embody the aspirations of her cause. As a result, when Alice Neel asked her to pose, she refused. Instead, Neel used photographs to make this likeness. FHG

Kate Millett
(born 1934)

Alice Neel (1900–1984)
Acrylic on canvas, 39³/₄ x 28¹/₂ ins
(101 x 72.4 cm), 1970
Time cover, August 31, 1970
Gift of *Time* magazine
NPG.78.TC588
© Estate of Alice Neel

In 1930, the Gershwin musical *Girl Crazy* opened on Broadway, and toward the end of the first act, an unknown singer named Ethel Merman mesmerized the audience with her rendition of "I Got Rhythm," in the course of which she held a high C for sixteen bars. As Merman later put it, by the time the applause died, "a star had been born. Me." Over the next five decades, her booming voice and brassy style were the main attraction of some of the most successful Broadway musicals ever, including *Anything Goes*, *Gypsy*, and *Annie Get Your Gun*—whose score included her trademark song, "There's No Business Like Show Business." Of her singing technique, Merman once said, "I just stand up and holler and hope that my voice holds out."

This image shows Merman dressed for the title role in *Annie Get Your Gun*. AEH

Ethel Merman
(1909–1984)

Rosemarie Sloat (born 1925)
Oil and acrylic on canvas, 89½ × 49¾ ins
(227.3 × 126.4 cm), 1971
Gift of Ethel Merman
NPG.71.50

The writer and political activist Gloria Steinem (left) emerged as a powerful voice for women's rights at a time when many Americans viewed feminism solely as a "white middle-class movement." In provocative articles such as "After Black Power, Women's Liberation" (1969), Steinem argued that inclusiveness across racial and economic boundaries was fundamental to the campaign for gender equality. To underscore the point that all women, regardless of race or class, had a stake in this struggle, Steinem joined forces with the leading child-care advocate Dorothy Pitman Hughes. In 1970, they embarked on a series of high-profile national speaking tours to galvanize grassroots support for women's issues. In this formal studio portrait published in *Esquire* magazine in October 1971, Steinem and Hughes signal their solidarity with the raised-fist salute first popularized by members of the Black Power movement. AMS

Gloria Steinem
(born 1934) and
Dorothy Pitman Hughes
(dates unknown)

Dan Wynn (1919–1995)
Gelatin silver print, 13^{15}/$_{16}$ x 14 ins
(35.4 x 35.5 cm), 1971
NPG.2005.121
© Estate of Dan Wynn

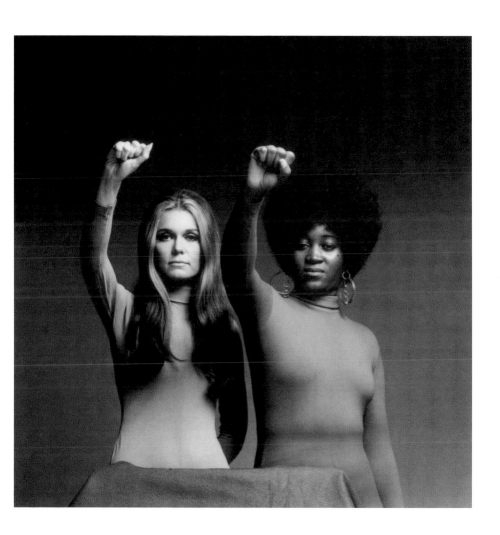

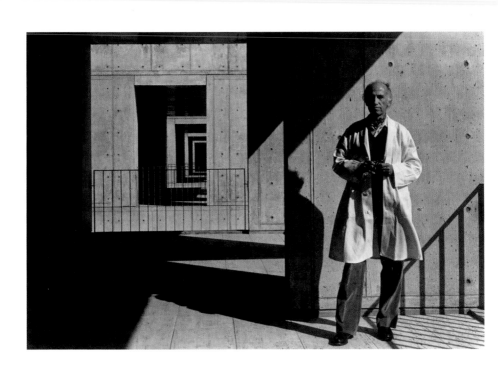

Pictured at the Salk Institute for Biological Studies, which he opened in 1963, Jonas Salk built his career on developing vaccines for influenza and poliomyelitis. In the early 1940s, Salk and Thomas Francis Jr. revolutionized immunology with their killed-virus vaccine for influenza, which produced protective antibodies without exposing recipients to the live virus of the disease itself. In 1947, Salk turned to producing a vaccine for polio, a viral infection capable of crippling or killing, and affecting young children especially. With the support from what is now the March of Dimes, Salk initiated experiments with killed-virus vaccines, reporting successful results in 1953. By 1955, the efficacy of the vaccine was clear, and it radically diminished the impact of polio in less than a decade. Unwilling to claim a patent, Salk asked rhetorically, "Could you patent the sun?" ACG

Jonas Salk
(1914–1995)

Arnold Newman (born 1918)
Gelatin silver print, $9^{1}/_{8}$ x $13^{5}/_{8}$ ins
(23.1 x 34.6 cm), 1975
Gift of Arnold Newman
NPG.91.89.78
© Arnold Newman/Getty Images

Elvis Presley grew up in the musical melting pot of Memphis, where his emerging talent was heavily influenced by local strains of pop, country, rhythm and blues, and gospel. As a young truck driver in 1953, he paid four dollars to record a song for his mother's birthday. Sun Records—then the label of such other young talents as Johnny Cash and Jerry Lee Lewis—soon signed him, and his first record, "That's All Right, Mama," was an instant hit. By 1956, thanks in part to a series of sensational television appearances, he was crowned the "king of rock and roll," with a string of recordings that included "Heartbreak Hotel," "Don't Be Cruel," and "Hound Dog." Since his death, Presley has emerged as an iconic entertainment figure, and his Graceland mansion has become one of the nation's most visited popular culture shrines. AEH

Elvis Presley
(1935–1977)

Ralph W. Cowan (born 1931)
Oil on canvas, 44 ins (111.8 cm) diameter, 1976–88
Gift of R.W. Cowan
NPG.90.114

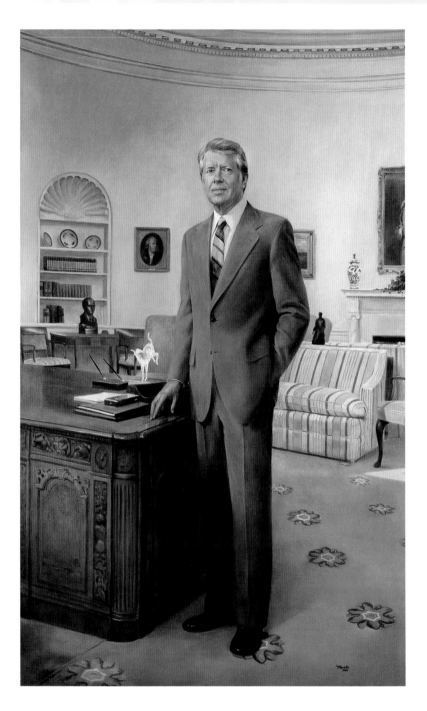

In the early stages of the 1976 presidential campaign, the experts hardly gave a second thought to Jimmy Carter's chances of winning the Democratic nomination, much less the White House. But the former Georgia governor's "can-do" image as a Washington outsider, along with his traditional populism, had great voter appeal, and in the final poll he emerged triumphant. Carter did not prove as popular in the presidency as he had on the stump, however, being blamed for problems such as runaway inflation. Nevertheless, his administration had some unalloyed successes, including a landmark peace agreement between Egypt and Israel, which would probably never have been reached without Carter's own dogged determination to make it happen.

Robert Templeton made the first sketches for this portrait at the White House in 1978. In the picture, Carter stands in the Oval Office, which is furnished as it had been during his administration. The donkey statuette on his desk was a gift from the Democratic National Committee. FSV

Jimmy Carter
(born 1924)

Robert Templeton (1929–1991)
Oil on canvas, 91^1/$_2$ x 56 ins
(232.4 x 142.2 cm), 1980
Gift of the 1977 Inauguration Committee
and Gallery purchase
NPG.84.154
© Estate of Robert Templeton

In making a portrait, one critic observed, Alice Neel "hurls shafts that hit the mark but do not sting," pinpointing the penetrating yet benevolent quality in the figure studies for which she is best known. Neel adhered to portraiture in the midst of the abstract expressionist movement and was consequently ignored by the art world until shortly before two retrospective exhibitions held during the early 1970s. "Life begins at seventy!" she said of her career's transformation to its newfound status.

In 1975, she began this shocking, endearing, and utterly unconventional self-portrait, which was not completed until 1980. As Neel noted, "the reason my cheeks got so pink was that it was so hard for me to paint that I almost killed myself painting it." A striking challenge to the centuries-old convention of idealized femininity, Neel's only painted self-portrait is wonderfully suggestive of her bohemian, bawdy character. BBF

Alice Neel
(1900–1984)

Self-portrait
Oil on canvas, $53^{1}/_{4} \times 39^{3}/_{4}$ ins
(135.3 x 101 cm), 1980
NPG.85.19
© Estate of Alice Neel, 1980

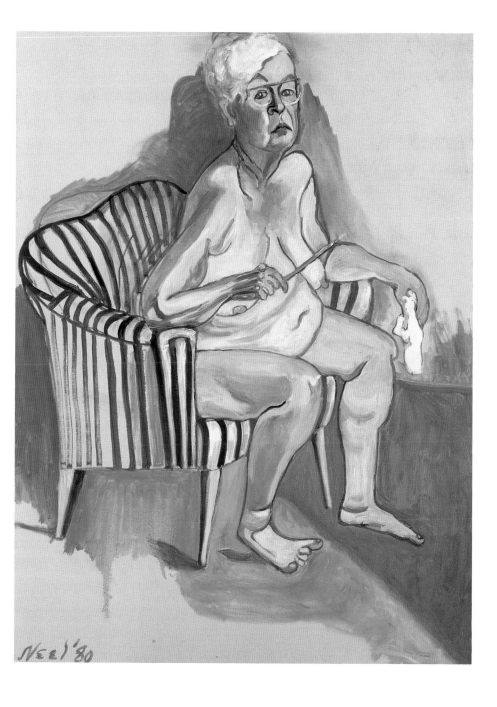

Neel '80

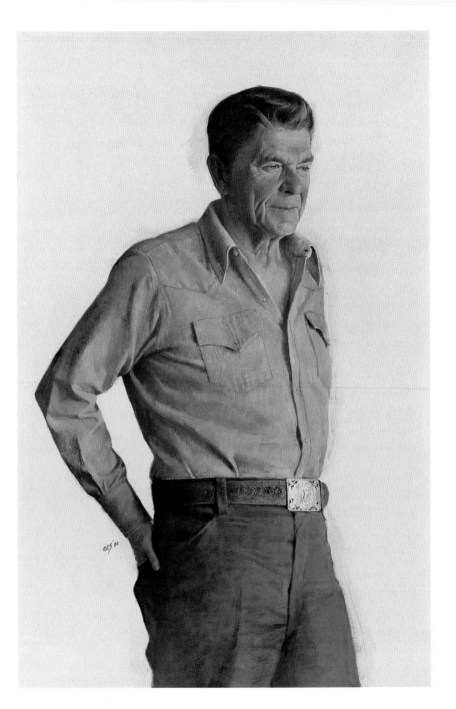

Time magazine placed this portrait of Ronald Reagan on the cover of its 1980 Man of the Year issue largely because Reagan had just claimed the White House in the recent November elections. More important, however, the triumph of Reagan's strong conservatism at the polls seemed to signal a marked change in America's political climate, and in his calls for reduced dependence on government he promised something quite different from recent administrations, Republican and Democratic alike. As *Time* put it, Reagan was not only Man of the Year; he was also "the idea of the year."

For this likeness, *Time* enlisted the services of Aaron Shikler, long considered one of the country's leading traditional portraitists. Among the traits characterizing Shikler's work is a sense of intimacy, which is achieved largely through sensitive lighting. FSV

Ronald Reagan
(1911–2004)

Aaron Shikler (born 1922)
Oil on paper, 25 x 16¼ ins
(63.5 x 41.3 cm), 1980
Time cover, January 5, 1981
Gift of *Time* magazine
NPG.84.TC140

As a chronicler of modern life and the anxieties revealed in suburban existence, John Updike has established himself as one of America's most eminent men of letters. His many novels, including *Rabbit, Run* (1960)—narrating the story of a former well-known athlete, Harry ("Rabbit") Angstrom, who, unable to recapture success when encumbered by marriage and small-town life, flees these responsibilities—are written in a prose style characterized by wit, detachment, and a penchant for detailing every aspect of a character's life. The prolific Updike has also published short stories, nonfiction, and criticism.

Alex Katz, a New York–based artist, first came to prominence in the early 1960s with the advent of the pop art movement. He is known for his larger-than-life portraits in which flattened forms fill the canvas. JGB

John Updike
(born 1932)

Alex Katz (born 1927)
Oil on canvas, 47½ x 33¾ ins
(120.7 x 85.7 cm), 1982
Time cover, October 18, 1982
Gift of *Time* magazine
NPG.84.TC156
© Alex Katz/Licensed by VAGA,
New York, NY

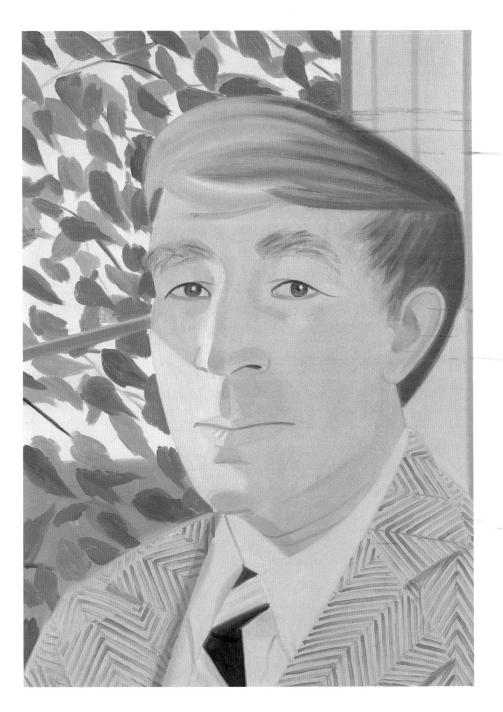

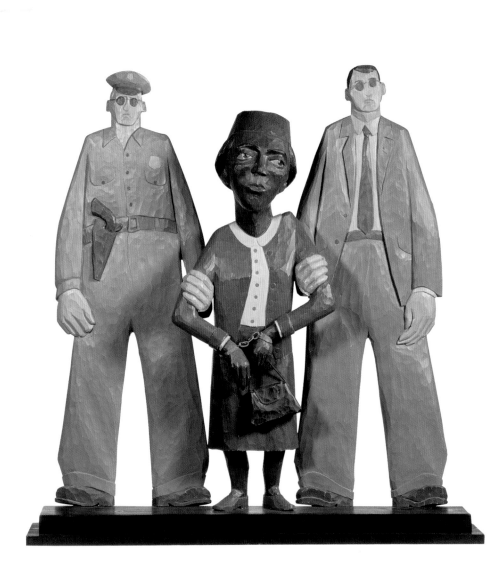

The modern civil rights movement in the United States began on a public bus in Montgomery, Alabama, on December 1, 1955. African American seamstress Rosa Parks refused the driver's request for her to give up her seat in the first row of the "colored" section to a white passenger: "I knew someone had to take the first step and I made up my mind not to move." Sculptor Marshall D. Rumbaugh depicts Parks as she is being escorted to jail by the arresting officers. In protest against the unconstitutionality of Alabama's laws requiring segregated seating on public conveyances, the Montgomery black community, led by twenty-seven-year-old clergyman Martin Luther King Jr. (see p. 220), organized a bus boycott that kept some 17,000 African Americans off the buses. The boycott lasted 382 days, until December 13, 1956, when the U.S. Supreme Court ruled such segregation laws as unconstitutional. CLW

Rosa Parks
(1913–2005)

Marshall D. Rumbaugh (born 1948)
Painted limewood, height 39 ins (99.1 cm)
(with base), 1983
NPG.83.163

New Orleans native Antoine "Fats" Domino was already a popular figure in the world of rhythm and blues when his songs such as "Ain't That a Shame" and "Blueberry Hill" (depicted here on the piano) exploded on to the rock-and-roll scene in the 1950s, attracting an enormous popular following.

The artist Red Grooms, who listened to rock and roll in his studio, considers this piece a tribute to Domino. Grooms's interest in three-dimensionality eventually led not only to his construction of huge sculptural pictoramas but also smaller-scale paper sculpture, including innovative printed and glued constructions like this exuberant and witty portrait. WWR

"Fats" Domino
(born 1928)

Red Grooms (born 1937)
Color lithographic sculpture,
17¹/₄ x 20³/₈ x 17³/₈ ins
(43.8 x 51.8 x 44.1 cm) vitrine, 1984
NPG.2003.78
© 1984 Red Grooms/Artists Rights Society
(ARS), New York

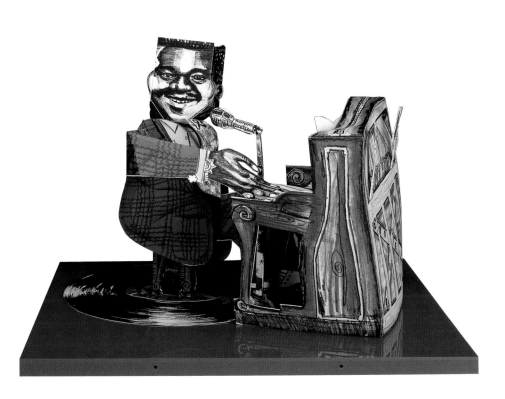

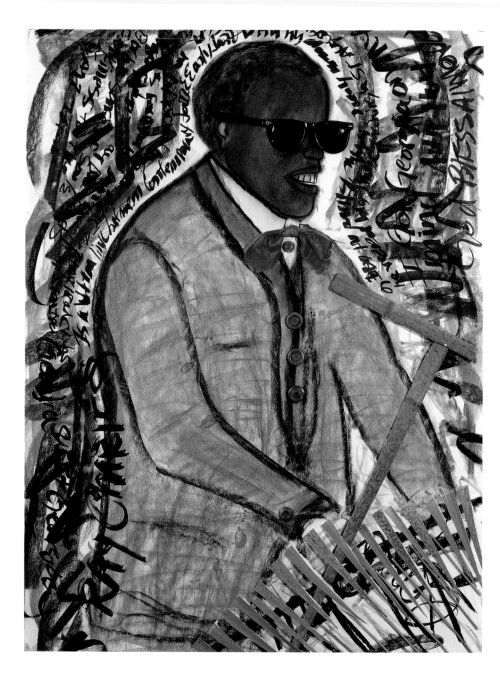

Few figures in twentieth-century popular music have exerted more influence than Ray Charles. By developing a style that blended the rhythm-and-blues tradition with gospel and rock and roll, Charles helped shape the music and style of other performers while creating such timeless hits as "Georgia on My Mind" and "Hit the Road, Jack."

Morgan Monceaux, an amateur musician with no formal training in art, used an innovative mixture of collage technique and found materials to produce a series of portraits of jazz greats. Here, discarded plastic sunglasses signify Charles's blindness, while strips of wood represent piano keys and a microphone stand. Handwritten words surround the figure like an aura, providing biographical details. Monceaux's portraits mirror the improvisational vitality of jazz and honor those musicians like Charles, whom the artist considers "the great rule-breakers of our time." WWR

Ray Charles
(1930–2004)

Morgan Monceaux (born 1947)
Graphite, pastel, felt-tipped marker, wood,
fabric, plastic, and adhesive on paper,
$40^3/8 \times 30^1/8$ ins (102.6 x 76.5 cm), 1992–94
Gift of Morgan Monceaux
NPG.2003.81
© Morgan Monceaux

Armed with superb natural talent, a keen competitive edge, and poise that set him apart from his rivals, Arthur Ashe made his way from the segregated playground courts of his youth to the pinnacle of the tennis world. Rated among the world's top ten players while still in college, Ashe reached the number-one ranking in spectacular fashion in 1968. After capturing the U.S. amateur title, he served an astonishing twenty-six aces in the final to become the first African American man to claim the U.S. Open championship. Ashe went on to record multiple tournament victories, including his memorable triumph over Jimmy Connors at Wimbledon in 1975. Following a heart attack that forced his retirement in 1980, Ashe dedicated his energies to humanitarian causes. He became a leader in the fight against AIDS in 1992, after revealing that he had contracted the virus through a blood transfusion. AMS

Arthur Ashe
(1943–1993)

Louis Briel (born 1945)
Acrylic on canvas, 48^{1}/$_{16}$ x 31^{15}/$_{16}$ ins
(122 x 81.2 cm), 1993
Gift of the Commonwealth of Virginia
and Virginia Heroes, Inc.
NPG.93.101

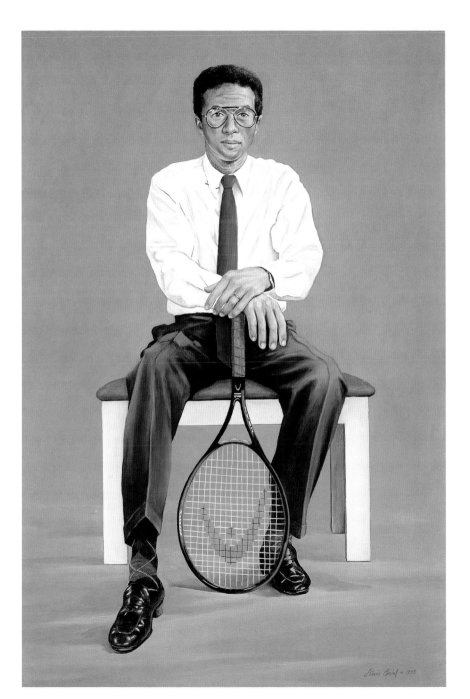

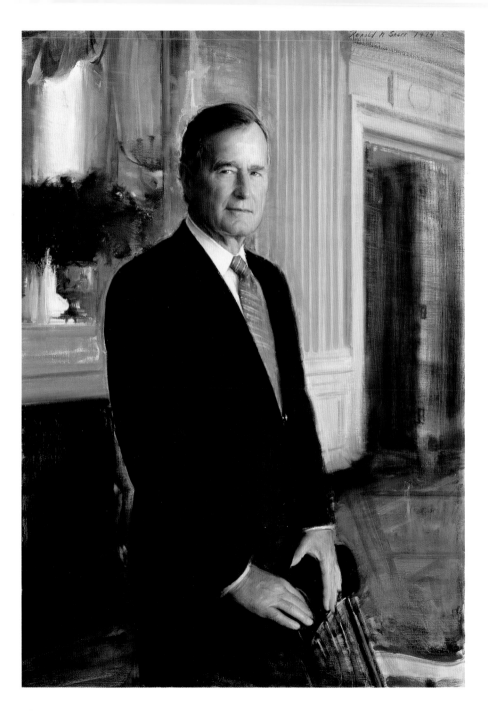

In the early 1960s, George H.W. Bush presided over a thriving oil business in Houston, Texas, but then turned to politics. By 1980, when he was elected Ronald Reagan's vice president, he had served as ambassador to the United Nations, envoy to China, and director of the Central Intelligence Agency. In 1988, he won the presidency.

Bush proved sure-footed in foreign policy, where, according to one observer, he was a master of both "timing and substance." More widely traveled than any other president, he managed the policy transitions prompted by the collapse of the Soviet Union and the end of the Cold War. Perhaps his greatest success was the alliance he crafted to thwart Iraq's forceful takeover of Kuwait in 1990.

Bush sat for this portrait at his home in Kennebunkport, Maine. The picture's backdrop, however, is the East Room of the White House. Among artist Ron Sherr's aims was to balance the formality of the composition with a warmth capable of drawing the viewer into the picture. FSV

George H.W. Bush
(born 1924)

Ronald Sherr (born 1952)
Oil on canvas, $49^{1}/_{4} \times 34^{1}/_{8}$ ins
(125.1 x 86.7 cm), 1994–95
Gift of Mr. and Mrs. Robert E. Krueger
NPG.95.120

At the beginning of his musical career, Lionel Hampton was a drummer until Louis Armstrong encouraged him to take up the vibraphone in the early 1930s. Hampton introduced that instrument to the jazz idiom and came to the attention of Benny Goodman in 1936. When Goodman formed the Benny Goodman Quartet, Hampton played "vibes" and went on to direct the group's recordings of such favorites as "Dinah" and "Exactly Like You." In 1940, Goodman disbanded the quartet, and Hampton struck out on his own, incorporating such musicians as Charles Mingus, Quincy Jones, and Charlie Parker into the Lionel Hampton Orchestra. Among the top bands in the country, the orchestra played all the popular clubs, as well as Carnegie Hall and Harlem's Apollo Theater. Hampton's high-energy spontaneity was legendary: "We got no routine," he once said. "We just act the way the spirit moves us." AEH

Lionel Hampton
(1908–2002)

Frederick J. Brown (born 1945)
Oil on canvas, 96¹/₈ x 72 ins
(244.2 x 182.9 cm), 1997
Gift of Mayor Rudolph Giuliani on behalf
of the people of New York
NPG.97.39
© 1997 Frederick J. Brown

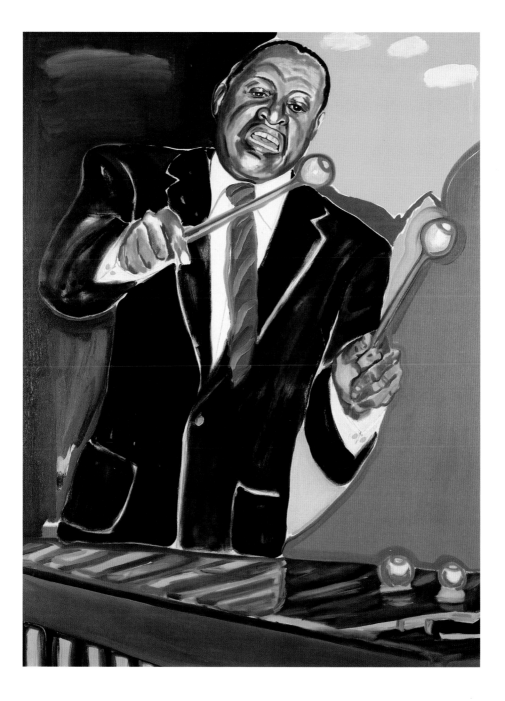

Toni Morrison has been writing about the experiences of African Americans since her first novel, *The Bluest Eye*, appeared in 1970. With the publication of each new work, both her fan base and her critical acclaim have grown, and she won the prestigious National Book Critics Circle Award for *Song of Solomon* (1977) and the Pulitzer Prize for *Beloved* (1987). In 1993, Morrison won the Nobel Prize for Literature, becoming the first black woman Nobel laureate.

This photograph by Deborah Feingold appeared on *Time* magazine's cover on January 19, 1998, in recognition of the publication of Morrison's seventh novel, *Paradise,* whose success may also be measured by its tremendous first printing of 400,000 copies. JGB

Toni Morrison
(born 1931)

Deborah Feingold (born 1951)
Chromolytic print, 13⅝ x 10⁹/₁₆ ins
(34.6 x 26.8 cm), 1998
Time cover, January 19, 1998
Gift of *Time* magazine
NPG.99.TC27
© Deborah Feingold, 1998/
CORBIS Outline

Faith Ringgold based her 1998 artist's book, *Seven Passages to a Flight*, and this accompanying quilt on autobiographical memories drawn from her own childhood in Harlem. Searching for an expression of the African American female experience, she started working in textiles in the 1970s. Her innovative story quilts drew inspiration from Tibetan "tankas," African piecework, and black American quilting traditions. Long an activist for racial and gender equality, Ringgold used flight here as a metaphor for overcoming the challenges that she encountered as a black woman. "Anyone can fly," she wrote in her award-winning children's book *Tar Beach* (1991). "All you have to do is have somewhere to go that you can't get to any other way." The imagery of flying, Ringgold has explained, "is about achieving a seemingly impossible goal with no more guarantee of success than an avowed commitment to do it." WWR

Faith Ringgold
(born 1930)

Self-portrait
Quilt with hand-painted etching
and pochoir borders on linen,
50⁹/₁₆ x 43¹/₁₆ ins (128.4 x 109.3 cm), 1998
NPG.2004.25
© Faith Ringgold, 1998

A distinguished biochemist, Maxine Singer earned the National Medal of Science in 1992 and led the Carnegie Institution from 1988 to 2002. Her groundbreaking research on DNA has improved our understanding of the development and structure of such genetic diseases as hemophilia. Singer notes that such experimentation, for which she helped devise ethical guidelines, "bring[s] closer the day when the ability to manipulate genetic material can be used for improving the lives of all humans."

Jon Friedman's study for a portrait commissioned by the Carnegie Institution reflects Singer's wide-ranging interests, from DNA to astronomy. Her influential *Genes and Genomes* (1990, with Paul Berg) appears beside a model of the Carnegie's Giant Magellan Telescope. Her family is pictured in the lower left, while Singer encourages two youngsters in the image directly below her book, illustrating her commitment to science education and public service. ACG

Maxine Singer
(born 1931)

Jon Friedman (born 1947)
Charcoal on paper, $48^3/_4 \times 30^3/_4$ ins
$(123.9 \times 78.1$ cm$)$, 2001
NPG.2005.54
© Jon R. Friedman

ACG: Anne Collins Goodyear
AEH: Amy E. Henderson
AMS: Ann M. Shumard
BBF: Brandon Brame Fortune
CLW: Carol L. Wyrick
DCW: David C. Ward
FHG: Frank H. Goodyear
FSV: Frederick S. Voss
HL: Hannah Lake
MP: Marc Pachter
JGB: James G. Barber
JLB: Jennifer L. Bauman
MCC: Margaret C. Christman
MSS: Molly S. Sciaretta
SH: Sidney Hart
WWR: Wendy Wick Reaves

Authors' initials

Index of Sitters

Index of Artists

First published 2006
by Merrell Publishers Limited

Head office:
81 Southwark Street
London SE1 0HX

New York office:
49 West 24th Street, 8th Floor
New York, NY 10010

merrellpublishers.com

in association with

National Portrait Gallery
Smithsonian Institution
8th and F Streets, NW
Washington, D.C.

Published on the occasion of the
reopening of the National Portrait Gallery,
Smithsonian Institution

A catalog record for this book is available
from the Library of Congress

British Library
Cataloguing-in-Publication Data:
Portrait of a nation
1.National Portrait Gallery (Smithsonian
Institution) – Catalogs 2.Celebrities –
United States – Portraits – Catalogs
3.Portraits – Washington (D.C.) – Catalogs
4.Celebrities in art 5.United States –
Biography – Portraits – Catalogs
I.National Portrait Gallery (Smithsonian
Institution)
704.9'42'0973'074753

ISBN (hardcover) 1 85894 345 0
ISBN (softcover) 1 85894 347 7

Produced by Merrell Publishers Limited
Compiled by Dru Dowdy, National
 Portrait Gallery
Designed by Untitled
Copy-edited by Elisabeth Ingles
Proof-read by Sarah Kane
All photographs by Marianne Gurley
 except p. 6, by Tim Hursley, and p. 10,
 by Rolland White

Printed and bound in China

Front jacket/cover Thomas Hart Benton
 and his wife Rita, see p. 136
Back jacket/cover Abraham Lincoln,
 see p. 96
Frontispiece Lionel Hampton, see p. 274